IMAGES
of America

SHOREWOOD
WISCONSIN

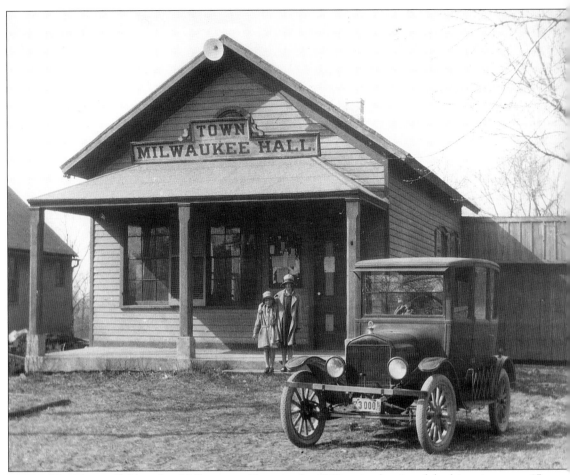

The Town of Milwaukee Hall, pictured here in the 1920s, was the site of the historic vote—45 for, 23 against—that approved the incorporation of the Village of East Milwaukee, thus making the area independent from the City and Town of Milwaukee. It was the beginning of the community now known as Shorewood. The town hall building is now located in Glendale behind Glendale City Hall, at 5909 North Milwaukee River Parkway.

Cover photo: Van Alstine's Grocery on Downer Avenue can also be seen on page 75.

IMAGES
of America

SHOREWOOD
WISCONSIN

Shorewood Historical Society

ARCADIA

Copyright © 2000 by Shorewood Historical Society.
ISBN 0-7385-0713-X

First Printed 2000.
Reprinted 2003.

Published by Arcadia Publishing,
an imprint of Tempus Publishing, Inc.
Charleston SC, Chicago, Portsmouth NH,
San Francisco

Printed in Great Britain.

Library of Congress Catalog Card Number: 00-102033

For all general information contact Arcadia Publishing at:
Telephone 773-549-7002
Fax 773-549-7190
E-Mail sales@arcadiapublishing.com

For customer service and orders:
Toll-Free 1-888-313-2665

Visit us on the internet at http://www.arcadiaimages.com

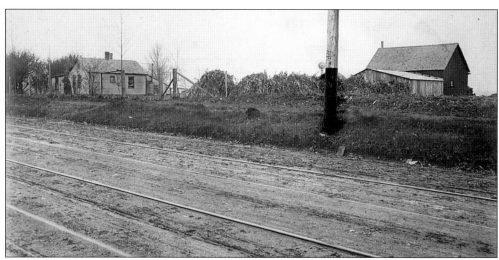

The Gores farm on Oakland Avenue is pictured here sometime after 1898, when streetcar tracks were laid north to Whitefish Bay. The Gores home still stands on the property. On an 1876 plat map, the property is marked F. Fischer. A structure is indicated on the property, which was purchased in September of 1868, as records indicate.

CONTENTS

ACKNOWLEDGMENTS

We look back with gratitude to all those who lived and worked in this village, now known as Shorewood, over the past 100 years. This is their history. It has been written a number of times, but never in the form presented here—a pictorial history with pictures from our archives. We are confident that the individuals who created the memories will enjoy this history. We hope that future residents will find this a pleasurable and easy way to learn the history of Shorewood's first century.

The writing and archival work has been shared by Nancie Baker, Frances Buelow, Dan Duecker, Barbara Hill, Sonja Ivanovich, Ruth Kissel, Margaret LaBorde, Dorothy May, Robert O'Meara, Virginia Palmer, Kay Ross, Shirley Spelt, and Jack Zweck. Advanced research by Sue Rebholz and the editorial consultation provided by Mary Anne Gross were invaluable. We wish to thank Margaret Mathews Sankovitz for melding the work of these contributors into a book.

We especially thank those who have shared photographs, information, and personal memories for use in this pictorial history of the Village of Shorewood.

We recognize Charles Talbot Sheldon (1883–1978), a village resident from 1920 to his death, who recorded the growth and development of the fledgling village with photographic images, and his daughter, Mary Sheldon Green, who donated a large collection of her father's photos to the Shorewood Historical Society's archives. Many of Sheldon's photos appear in this book, and Mary, as a young girl, is in many of the photos.

Special citation is given to materials from which information was culled, including *Shorewood* (A Federal Writers' Project of Wisconsin, 1939); *Profile of Shorewood* (compiled by the League of Women Voters of the North Shore—Milwaukee County, 1978); *Shorewood Now and Then* (produced by the T.A.G. Kids, gifted and talented students of the Shorewood School District, 1987); *The History of St. Robert Parish, 1912–1987* (1987); *A History of Shorewood School Buildings* (unpublished manuscript by Bernard Greeson); and the *Shorewood Herald* newspaper and its predecessors.

—The Shorewood Historical Society

INTRODUCTION

The Village of Shorewood, nestled between Lake Michigan and the Milwaukee River and bordered by the City of Milwaukee and the Village of Whitefish Bay, is only 1,002 acres—about 1.5 square miles—but it is a village tall in stature and big in heart.

The history of Shorewood only extends back to 1900, but the area is rich in pioneering lore and has had many names—Mechanicsville, Cementville, East Milwaukee, and, finally, Shorewood, which is unquestionably the most descriptive of the area.

Heavily wooded, and traveled and hunted by Native Americans, the present site of Shorewood was first seen by European Pere Jacques Marquette, a French Jesuit explorer, and his companions. They were traveling Lake Michigan by canoe and passed the bluffs of the area on November 23, 1674, according to Father Marquette's diary.

When the United States government purchased land east of the Milwaukee River from the Menominee Indians, the arrival of settlers from the eastern United States was not far behind.

A mill was built in 1834 by Dr. Amasa Bigelow on the east bank of the river, just south of the present Capitol Drive bridge. The mill was the first industrial enterprise in the area, but was short-lived.

In 1835, Daniel Bigelow took out a claim at a land sale and planned the first settlement on Shorewood's site. Platted March 15, 1836, Mechanicsville had a river, a dam, and two sawmills. The Depression of 1837 showed that, in spite of its water power and mills, the settlement still had most of its promise on paper.

In 1841, the first permanent settler, Thomas Bare, purchased 90 acres for $225 just east of the river and north of Capitol Drive. Returning from the Civil War, his son Ralph purchased 40 acres from his father and built a house that was still standing in the latter part of the 20th century in the area now occupied by the Channel 6 TV tower.

In 1872, a Milwaukee resort proprietor, realizing the potential of the region, opened Lueddemann's-on-the-River. The resort was popular for many years, with many visitors arriving on boats from Milwaukee. Successive owners renamed the park Zwietusch's Mineral Springs Park, reflective of the natural phenomena of the landscape; Coney Island, 1900; Wonderland, 1905; and Ravenna, 1909. The era of the resort-amusement park ended in 1916, but the area, Hubbard Park, remains, for the most part, a place of relaxation and entertainment for villagers.

The advent of the "iron horses"—the steam engines and cars of the Northwestern Union Railway—opened the area to development when the company built the first tracks across the

Shorewood plateau in 1873 on a right-of-way cutting through Thomas Bare's orchard east of the river.

In 1875, J.R. Berthelet discovered that the limestone of the region could be ground into a natural cement, and in 1876, the Milwaukee Cement Company built a plant on the east bank of the river at the foot of Richards Street (now Wilson Drive). The area became popularly known as Cementville. The mills were discontinued in 1909.

In 1886, the Whitefish Bay Railway Company was organized to provide transportation north to Whitefish Bay. Tracks were laid through the Shorewood area, which brought crowds to the amusement parks on the river, to the Milwaukee Country Club on the lake bluffs, and to the many river and lake picnic areas. Known as the Dummy Line, it lasted until 1898, when the Milwaukee Electric Railway and Light Company extended its electric line for streetcars on Oakland Avenue to Whitefish Bay.

Public transportation opened the area to city dwellers, thus attracting new residents. These residents—almost 300 strong—were becoming increasingly dissatisfied with the allocation of tax moneys in the Town of Milwaukee. A small group met in Pete Mead's tavern at the northeast corner of Oakland and Newton Avenues and decided to incorporate the territory north of Milwaukee and east of the river into a separate village. A petition was filed in the circuit court of Milwaukee on March 14, 1900, for the incorporation of the Village of East Milwaukee, and on August 21, 1900, the petition was granted. Shorewood was born!

The small village had grown to 1,255 residents by 1913, and each year the number of people settling in East Milwaukee grew. Finally, in a 1917 effort to distinguish the village from the city, the residents decided to change the name to Shorewood. This name was more reflective of the area, although the dense woods that had characterized it were disappearing as more and more subdivisions were constructed, streets were built and paved, and businesses were opened.

As wealthy Milwaukee industrialists moved out of the city to the village along the lake, it became known as the "Gold Coast." The average resident of Shorewood was not a "Gold Coaster," but a steadily employed professional, businessman, or tradesperson, interested in living in a well-organized, up-to-date community. The popularity of Shorewood as a place to live expanded the population, and at the beginning of the 21st century, 14,000 people now live in Shorewood.

This pictorial history of the first 100 years of Shorewood is not intended to be definitive or complete. With pictures available in the Shorewood Historical Society archives, the writers have woven a story of the people of Shorewood and their efforts to build and maintain a residential area served by small business, educated by quality schools, and made comfortable by parks and sports facilities—a cosmopolitan village within a large metropolitan area, separate but closely connected to the areas surrounding it.

One

Participatory Democracy
Makes Good Government

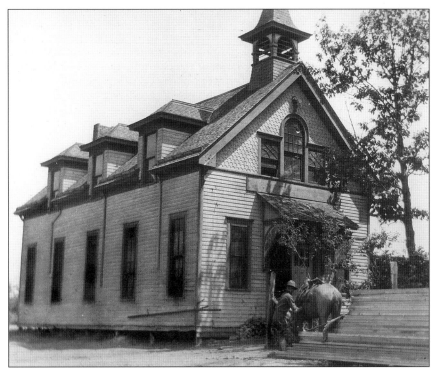

When Shorewood was East Milwaukee, the first town hall building was the former "little pink schoolhouse," just north of East Capitol Drive, facing North Oakland Avenue. When the village offices moved into the present site on North Murray Avenue in 1916, this building was used by the Light Horse Cavalry Squadron to store hay for its horses. This image was taken c. 1896.

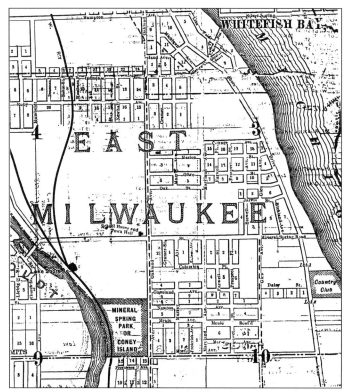

A 1901 map of East Milwaukee, which later became Shorewood, showed the "little pink schoolhouse" and town hall, at what became Capitol Drive and Oakland Avenue. The amusement park was just west of Oakland Avenue, and the Milwaukee Country Club was at the lakefront.

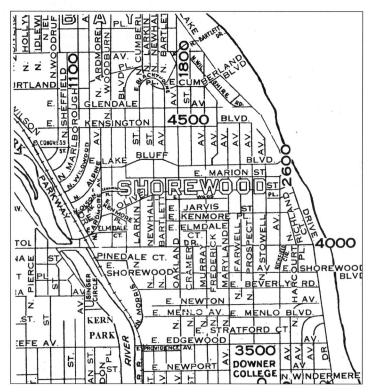

By 1923, as shown in this map, Shorewood had acquired its modern layout and street names.

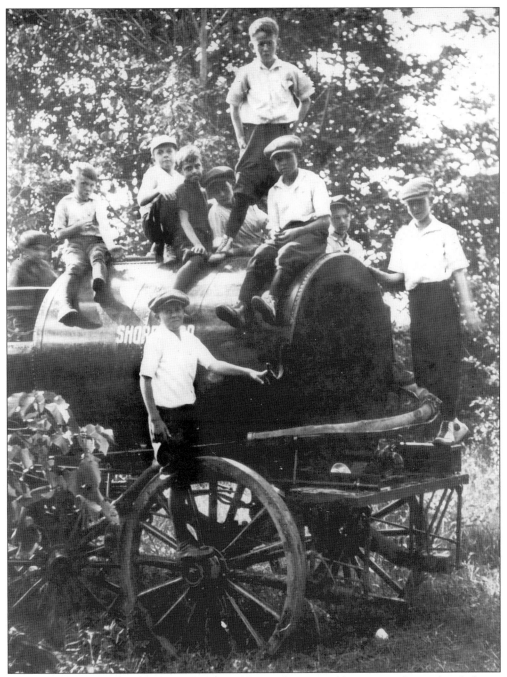

Young boys swarm over Shorewood's original horse-drawn water wagon in this undated photo. Water was sprinkled regularly on the village's unpaved streets to subdue the dust. In 1913, Richland Court became the community's first paved street.

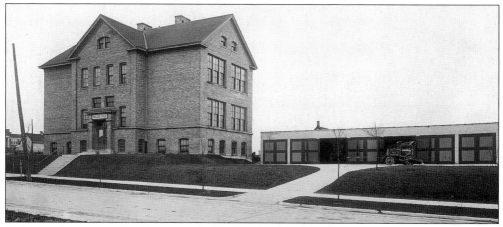

Built as a four-room schoolhouse in the Town of Milwaukee district in 1908, this building was purchased by the Village of East Milwaukee in 1916 to house its offices. This photo was taken soon thereafter. Named to the National Register of Historic Places in 1984, the hall went through several remodelings that included the addition of windows and a portico on the front. Note the horse-drawn wagon at right (street sweeper at rear).

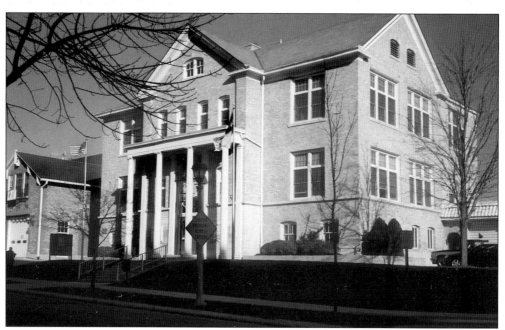

The present-day Shorewood Village Hall, which had been painted white in the middle of the century, now sports its original brick color, plus a handicap-accessible, rear-entry addition.

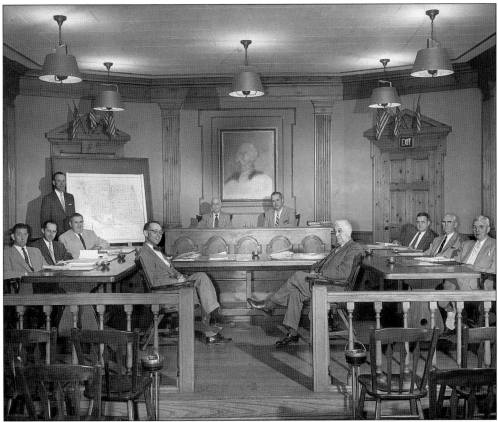

In Shorewood's early days, the Village Board alone was responsible for management. A village manager was hired in 1928, as a trustee-manager form of government was adopted. Pictured here is the 1956 board. They are, from left to right, as follows: trustees G.W. Embury, J.E. Cannon, village engineer Robert Duncan (standing), trustee J.E. Palmer, manager Charles Henry, Clerk J.L. Jones, President N.A. Lemke, attorney H.O. Wolfe, trustees R.E. Kierstead, B.D. Larkin, and A.L. McLean. (Courtesy of Richard C. Borgeson.)

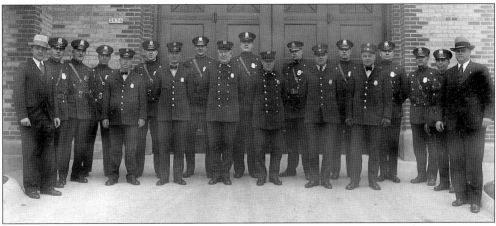

In 1933, members of the Shorewood Police Department pose with Village Manager Harry Schmitt, on the left, and Police and Fire Chief Emil F. Bartels, on the right.

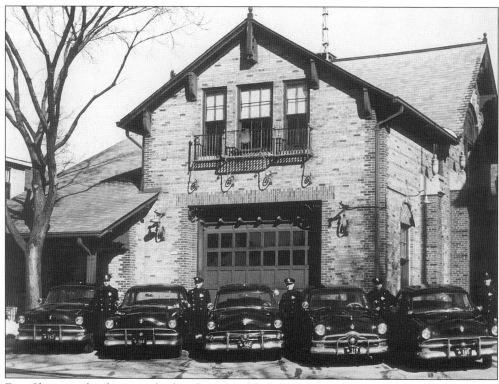

Five Shorewood policemen display their new black squad cars in front of the police and fire station on Murray Avenue in 1960.

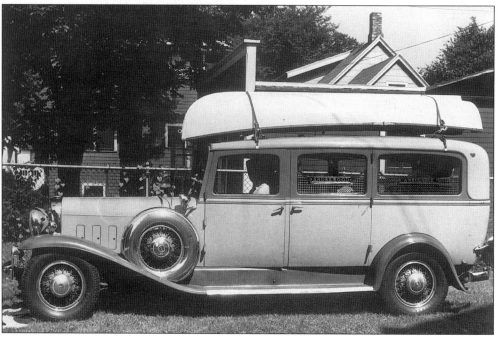

Shorewood's first ambulance was this Lincoln, equipped with a rescue boat on top. The vehicle was purchased from the Fass Funeral Home in 1929 (Marty Mercen reproduction).

In the 1920s, Officer Emil Bartels (later police and fire chief, pictured at left) and Marshall Nicholas Zehren (right) pose with a young girl.

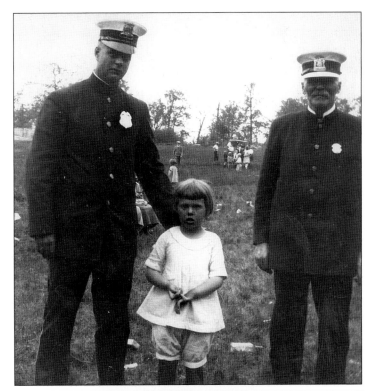

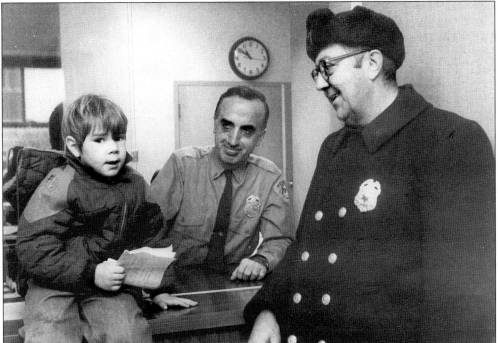

The Shorewood Police Department worked closely with crossing guards. In this photo, Lieutenant William Cary (later chief of police) meets with four-year-old Tim Corwin and crossing guard George Goodnature.

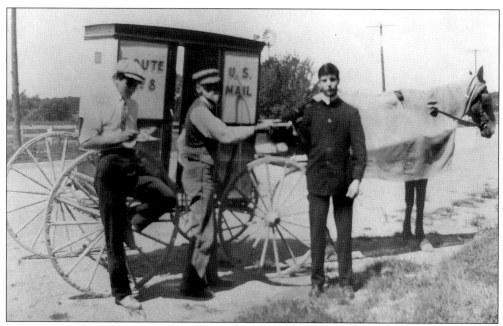

In 1900, when the Village of East Milwaukee was incorporated, the first post office was on wheels.

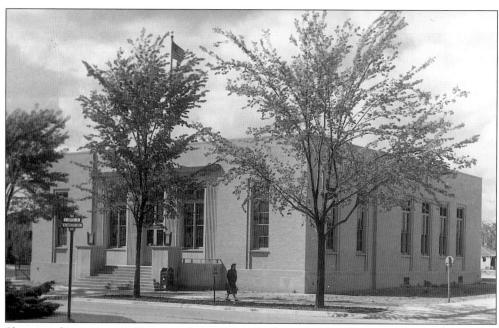

Shorewood's new post office was dedicated with the issuance of a first-day postal cover on October 1, 1937. Like many government buildings of the 1930s, it has clean Art Deco lines. The brick structure is trimmed in limestone with a stylized eagle above the entrance and granite steps. A handicap ramp was constructed later.

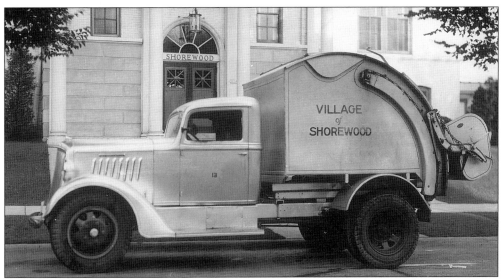

Designed especially for Shorewood, these handsome new garbage pickup trucks were put into operation about 1935, as equipment changed rapidly at mid-century. Refuse was collected from garbage cans kept at the rear of homes and buildings.

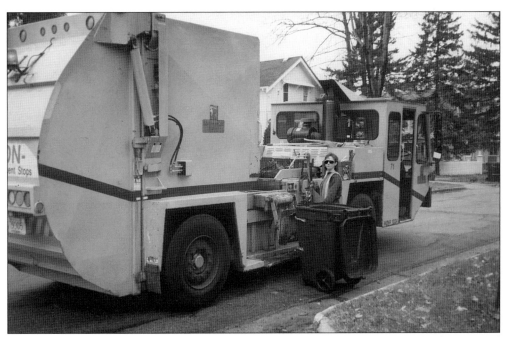

Shorewood now uses these vehicles to pick up refuse that residents leave at curbside in special containers. One person operates the vehicle, which is seen here in 1999.

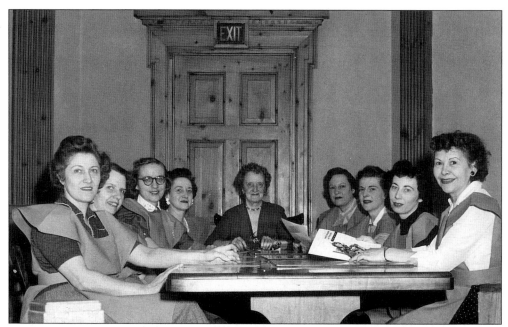

Mrs. Irene Hugunin, a registered nurse, developed a health volunteer program for the Shorewood Health Department that was not matched by any other local community. In this picture, Mrs. Hugunin (center) meets with volunteers in the village hall courtroom. The department was formed in 1925.

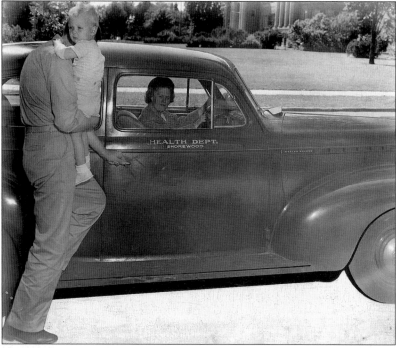

The Shorewood Health Department provided an automobile for the staff nurses. Mary Harrington, department secretary, is pictured visiting with an unidentified parent and child while on a business call.

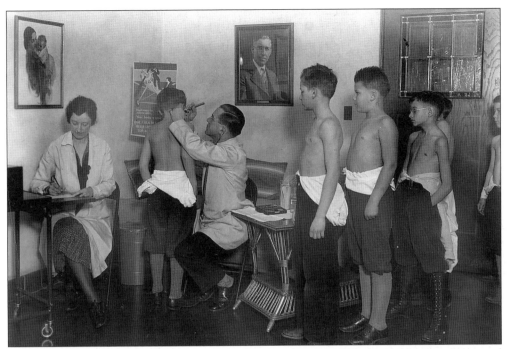

The physician in charge of Shorewood's health program provided physical examinations and immunizations with the assistance of the public health nurse.

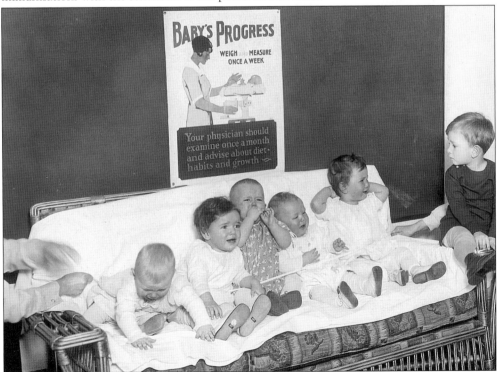

Preschoolers were brought to the school health office for physical examinations, and instructions on the care and feeding of children were given to mothers.

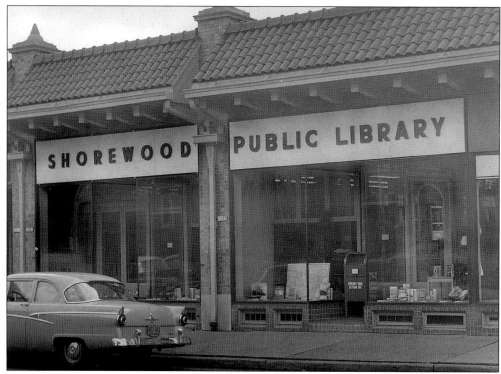

Since the early 1900s, the Shorewood Library has inhabited various locations, including the basement of the village hall and five different storefront locations. This site, in the 2200 block of East Capitol Drive, was the last before the new library building was opened in 1965. The first library had opened in 1903 in the combination town hall/schoolhouse on the northwest corner of Oakland Avenue and Capitol Drive.

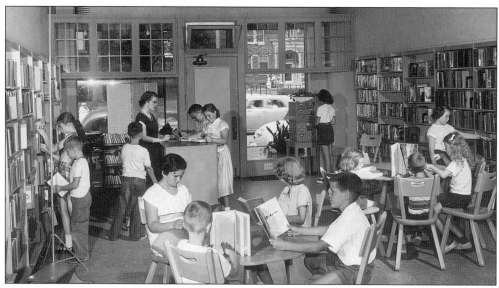

Children filled the small library space at 2209 East Capitol Drive before Shorewood had its own library building.

This book stack area was added to the library in the 2200 block of East Capitol Drive in 1957.

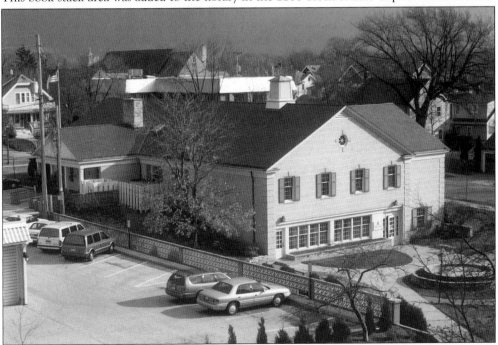

In May of 1965, a structure built for the purpose of housing a library was formally dedicated. A Library Planning Commission had been appointed in 1952 to study the village's library needs. As a new century begins, discussions and debates arise over expanding the existing library or constructing a new building.

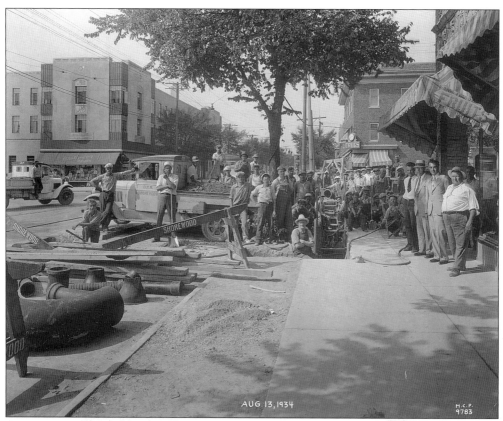

Workers on a federal jobs project at the corner of North Oakland Avenue and East Capitol Drive pause for a picture on August 13, 1934.

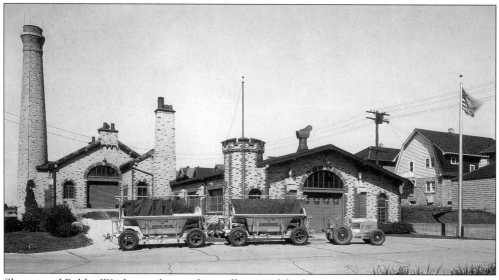

Shorewood Public Works employees show off some of the latest equipment at the Public Works yards, just west of North Morris Boulevard at Beverly Road, in this undated photograph. Note the covered cars of the "garbage train," which was pulled by tractor.)

Two
RAIL, WHEEL, AND BRIDGE
BRING CITY TO COUNTRY

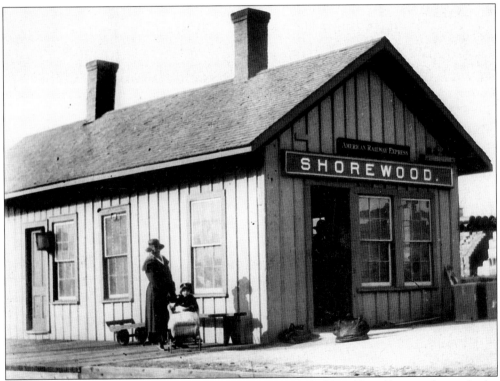

In 1921, Mrs. Charles Sheldon and her daughter, Mary Sheldon (Green), waited outside the Shorewood Station alongside the Chicago and Northwestern Railroad tracks that were laid near the Milwaukee River. The depot was closed in 1927, when the Lake Shore Branch of the C&NW was discontinued.

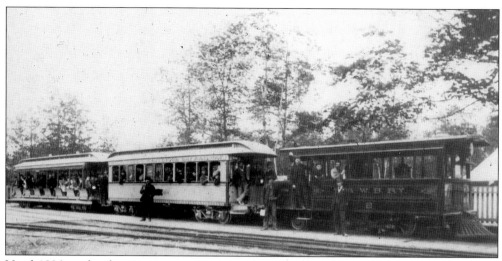

Until 1886, no local transportation system was available for the upper east side of Milwaukee since the "horse car" (street cars on tracks pulled by horses) service extended only to North Avenue. In 1886, the Whitefish Bay Railway Company was organized to provide transportation north to Whitefish Bay. The train consisted of a 12-ton locomotive and three passenger coaches—one enclosed and two open summer coaches—seating 70 persons.

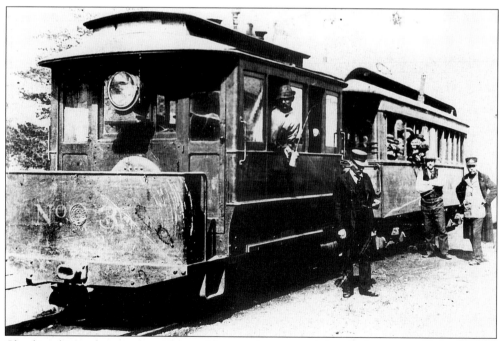

Checking his pocket watch, a Dummy Line conductor stands beside the engine. Following the first run of the new railway in 1888 that left a wake of broken buggies, overturned wagons, and runaway horses, a life-size wooden horse was mounted on a low flat car in front of the engine to make the innovation less terrifying. The name "Dummy Line" stuck long after the wooden horse was retired.

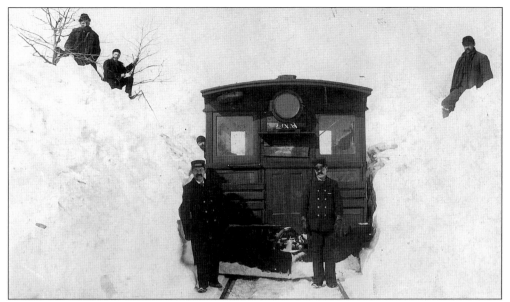

The Dummy Line train is deep in a tunnel of snow in the Winter of 1898 (February 2–29, 1898; 26 inches) between Maryland and Frederick Avenues at about Lake Bluff Boulevard. The tracks were laid north on College Avenue (Downer) to midway between Newton Avenue and Beverly Road, west to Maryland Avenue, north to Lake Bluff Boulevard, and northwest out of the village near the present intersection of Frederick and Glendale Avenues.

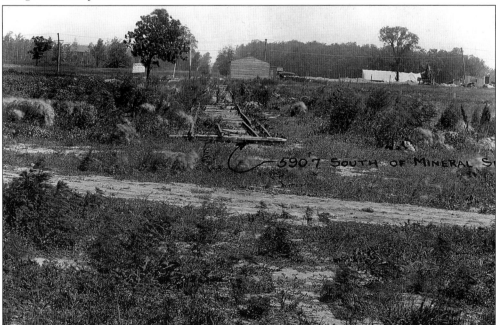

The Dummy Line tracks, unused since 1898, were still visible in the muddy, weed-filled fields in this July 13, 1913, picture. The temporary wooden structure used by St. Robert Parish from July to October 1913, is in the upper center of the picture. In 1898, the Milwaukee Electric Rail and Light Company had extended its electric line north on Oakland Avenue to Whitefish Bay. (Courtesy of G. A. Brackett.)

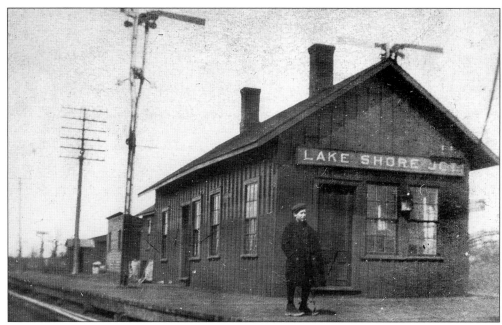

In 1873, the Northwestern Union Railway built the first tracks across the Shorewood plateau in the western part of the area, east of the Milwaukee River. A tiny rail station, seen here in 1905, was built in 1891 to serve riders on the Lake Shore Branch of the C&NW Railroad (located approximately where Bakers Square Restaurant is situated, south of Capitol Drive and just east of the bicycle trail).

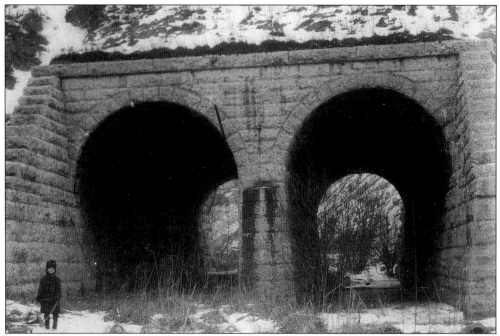

The C&NW tracks passed over a two-way tunnel, which is still in existence and leads to Hubbard Park. It is seen here in 1924. The tunnel was constructed to allow cut ice, which was needed for refrigeration, to be transported from the Milwaukee River during winter.

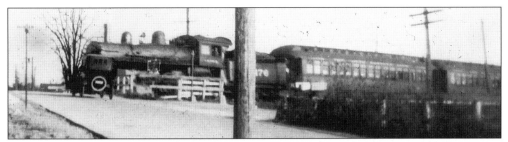

About 1925, the C&NW Railroad began an extensive project of rerouting its tracks because of interference with street traffic. Tracks in Shorewood ran at street level north along the river. At the principal grade crossing at Capitol Drive, a police car was present every day to control traffic. Sometimes as many as 50 cars were backed up waiting for the fast Minneapolis-bound train to pass. This picture dates from 1924.

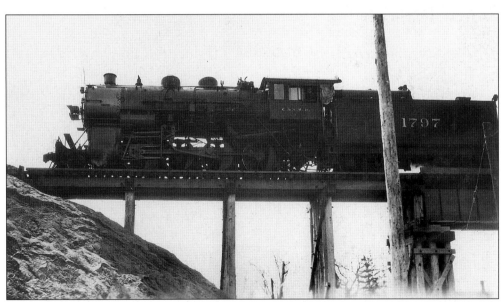

It took about two years to build the Capitol Drive trestle, dig out the underpass (see photo), and install the four tracks to East Hampton Avenue in Whitefish Bay. In the 1970s, freight and passenger services were discontinued, and the tracks were removed south to North Avenue. Today, a bike trail is located on the railroad right-of-way. Engine 1797 crossed the trestle at Capitol Drive in this 1925 photo.

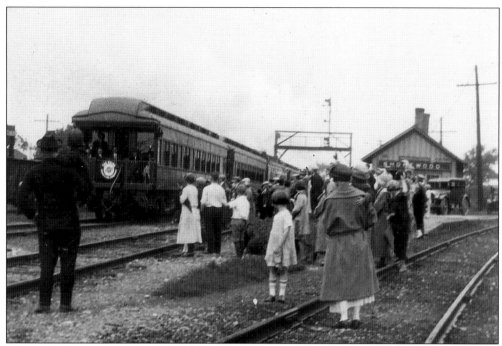

June 2, 1925, President Calvin Coolidge's train stopped at the Shorewood Station on the south side of Capitol Drive. Residents turned out to greet the 30th president of the United States.

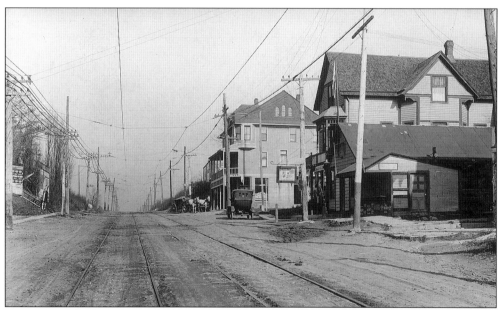

Streetcar tracks were seen on Oakland Avenue by 1900. Streetcars pulled up to the entrance of the amusement park to bring stylishly dressed ladies and gentlemen for a day's outing. In this picture, taken from just south of Newton Avenue, there are double tracks. Note the horse-drawn wagon in front of the three-story building in the upper right (Mead's Tavern). (Courtesy of A.J. Breitwish.)

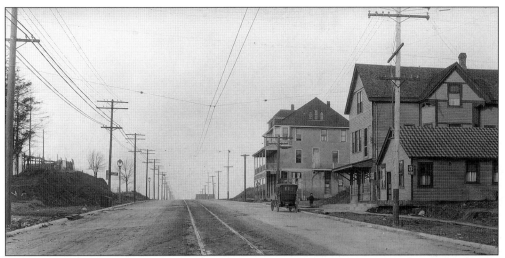

In 1918, Oakland Avenue was citified with curb, gutter, and sidewalks. In this December 14, 1918, photo, the paved improvements and harp street lights can be seen. Note that the three-story building in the center (Adler's Tavern) has lost its fancy second-story porch and the hanging sign out front. Also, the small building to the right is gone, but the car remains parked out front. (Courtesy of A.J. Breitwish.)

The Milwaukee Electric Railway and Light Company purchased the southern portion of the land that had been occupied by Ravenna Amusement Park when it closed in 1916. An office building was constructed just north of Edgewood Avenue (present River Park apartments site), and car barns were constructed to the west. In 1968, the company terminated operations there, and the village purchased the property in 1970. This photo dates from 1916.

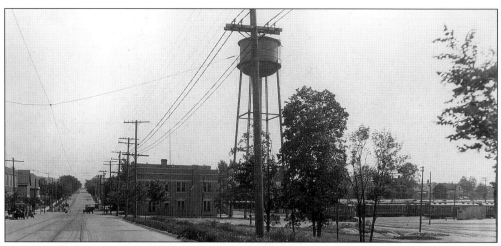

In this 1922 photo, streetcars awaiting service are visible to the right of the Transport Company building on Oakland Avenue. The street is paved, there are two sets of tracks, a water tower has been built on the property, and several cars of the era are on the street.

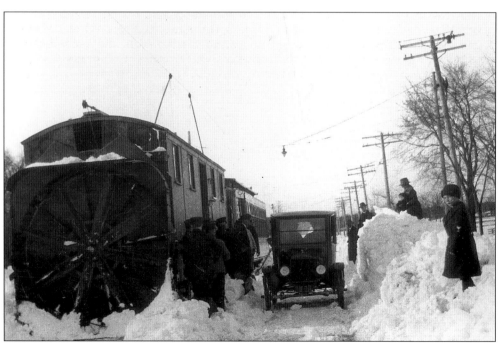

When heavy snow threatened the progress of the streetcars, a streetcar snowplow was sent out to clear the tracks. A rotary snowplow is shown at Downer and Edgewood Avenues on April 16, 1921, following a blizzard. The fan-like plow on the front of the streetcar cleared the snow. A vintage Ford auto squeezes in between the plow and the snow drifts.

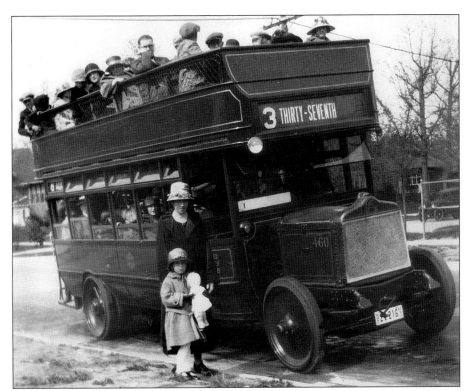

A double-decker sightseeing bus was added to the transportation scene in warm-weather months. This bus was photographed in 1924, at the corner of Edgewood and Maryland Avenues. Florence Branden Firer, a long-time resident, recalled taking the double-decker for Sunday entertainment from Edgewood and Maryland Avenues to downtown, west on Wisconsin Avenue almost to Wauwatosa, and back home again.

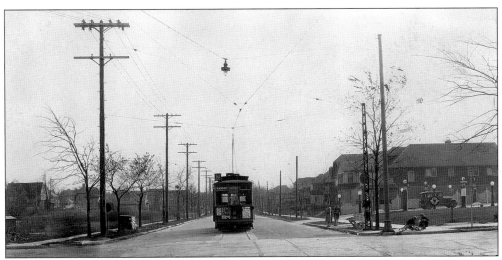

The Number 10 streetcar comes to the end of the line at Downer Avenue and Capitol Drive in this November 1929 photo. Note the filling station on the right corner and the vacant lot on the left corner where the Ridgefield Circle area was developed in later years. The area served by the Number 10 is now served by the Number 30 bus.

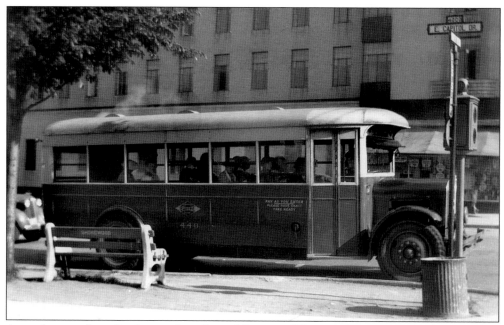

An early type of gasoline bus used on Capitol Drive and Downer Avenue was similar in style to a school bus. A June 1937 photo shows such a bus traveling eastbound on Capitol Drive at Oakland Avenue.

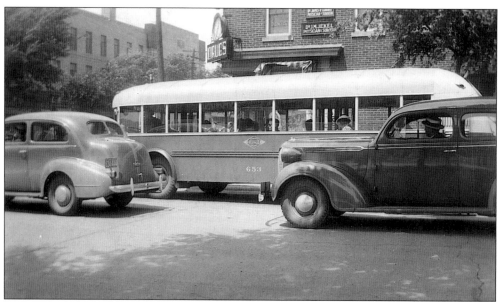

A small type of gasoline bus is pictured traveling westbound at Capitol Drive and Oakland Avenue in this January 1937 photo.

January 29–31, 1947, the Milwaukee area was hit by a blizzard, and transportation, including streetcars, was stalled in huge drifts. In this 1947 photo, only pedestrians are moving in the streets around the stalled Number 15 on Oakland Avenue at Lake Bluff.

In the 1950s, the Number 30 line terminated in Shorewood. A bus is pictured here leaving Oakland Avenue traveling west from the turn-around at Kenmore Place. The North Shore Presbyterian Church and Sendik's Fruit Market are in the background of this photo. The A&P parking lot is in the foreground (presently Walgreens parking lot).

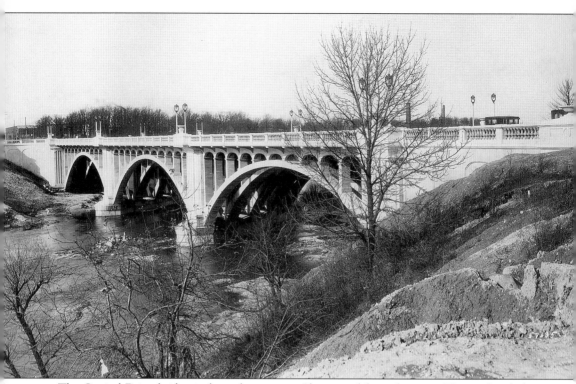

The Capitol Drive bridge is the only access to Shorewood from the west. This undated photo, taken from the south side of the bridge looking west, shows the Milwaukee harp lighting fixtures, a few old cars, and the area west of the river now occupied by Radio City—WTMJ Radio and TV. In 1927, the iron bridge across the Milwaukee River was replaced by a new bridge that was the width of two automobiles. The bridge served well until 1983, when work was begun on a two-roadway bridge with four traffic lanes separated by a median strip. In 1997, the bridge surface was overhauled, and new lighting fixtures were installed.

Three
A Century of Homes

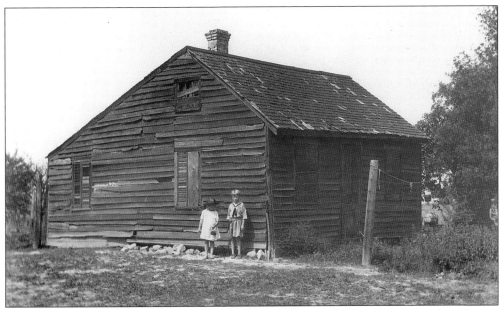

The Wunderlie home was the first one built in the old Town of Milwaukee. It stood on the site of Walgreens in the 4000 block of Oakland Avenue. It was originally built of logs in the mid-1800s; siding was added later. On an 1876 plat map, the name of P. Wunderlie is on a lot at what is now Oakland and Glendale Avenues. No structure is indicated.

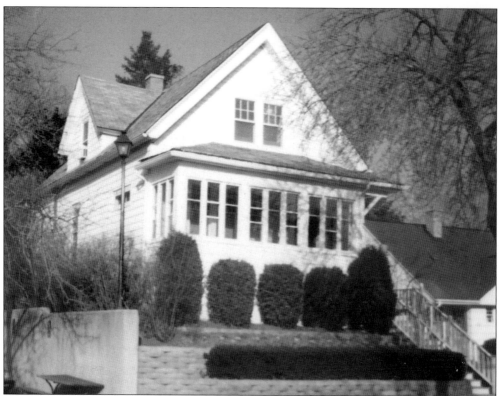

Until recently, the Domer family name had been synonymous for generations with the oldest existing home in Shorewood. Built in 1888 at 1814 East Newton Avenue, the home (pictured above) was in the Town of Milwaukee. The property included a barn where a small dairy farm was operated by Charles Domer, the first village treasurer for East Milwaukee when it was incorporated in 1900. The barn, updated and modernized, remains on the property (pictured below).

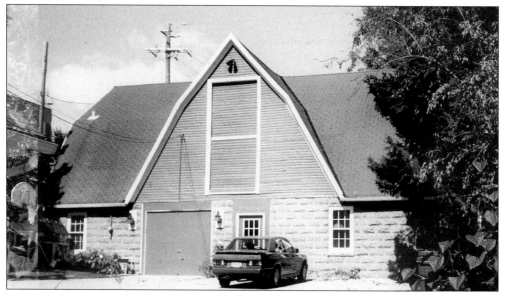

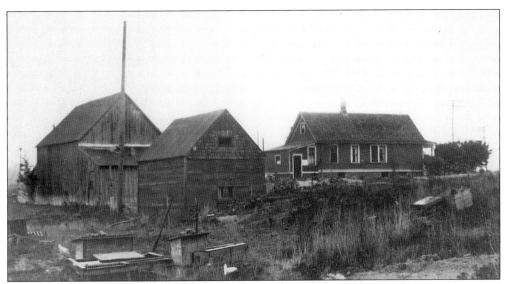

Considered the second oldest existing home in Shorewood, this charming cottage (pictured below), at 4221 North Murray Avenue, was built in 1889 on the site of the Engelbert Benzing farm (above in 1912 photo). The farm and surrounding land evolved into a newly developed subdivision. Benzing reportedly graded lots with his team of horses, and his wife sold produce from the farm door-to-door.

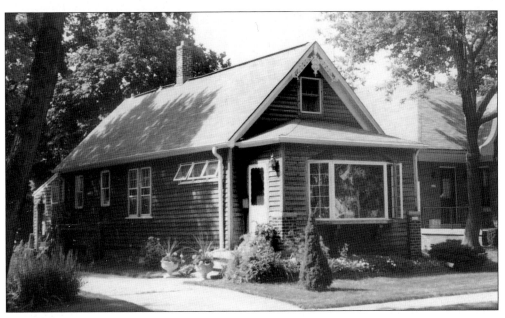

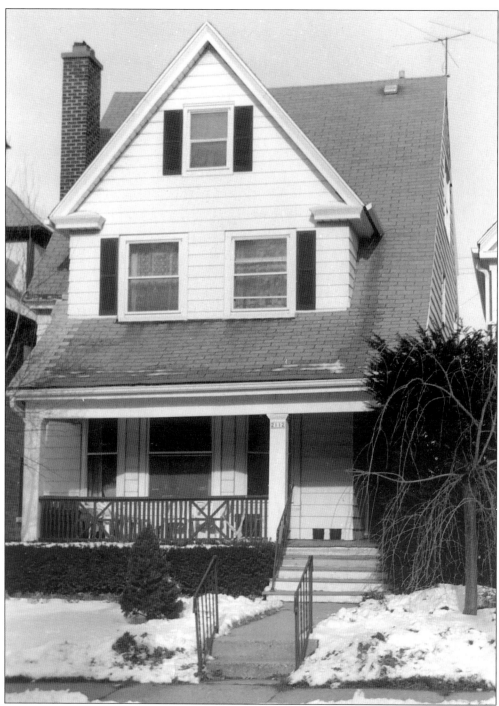

A unique "half house" remains at 2112 East Edgewood Avenue, having been "split" from an imposing home twice its size. Originally built in 1900 at the northeast corner of Edgewood Avenue and North Frederick Avenue, the house was a model for a subdivision. In order to accommodate two lannon-stone homes planned to abut the property, the original home, with its east side sheared off, was moved to its present location.

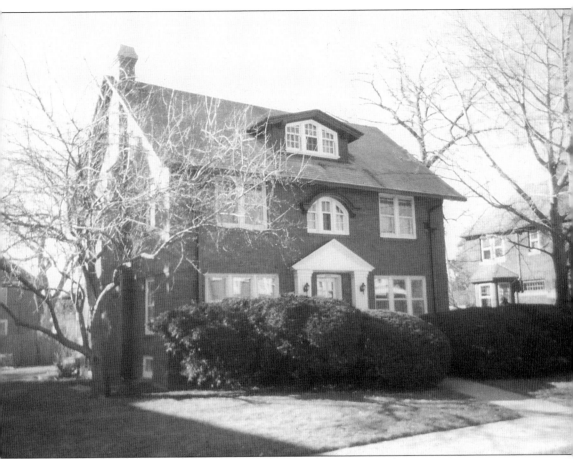

One of the earlier houses built in this area of Shorewood, this three-story brick home at 4059 North Richland Court dates to 1914. It is attributed to well-known builder George Schley. Richland Court became the first paved street in Shorewood (then East Milwaukee) in 1913 and served as an impetus for further construction. By 1917, there were 470 homes and 1,600 people in Shorewood.

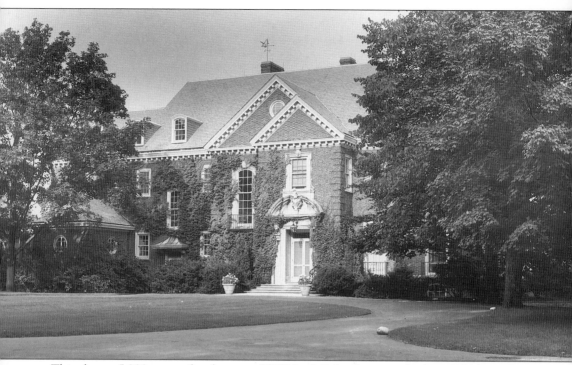

This elegant 5,300-square-foot home at 3510 North Lake Drive was built in 1923 by architects Walter Judell and Harry Bogner for Fred Vogel, then president of Pfister and Vogel Tannery. It is a Milwaukee County Landmark, and it is typical of what were known as "Gold Coast" homes, built for business and professional people who preferred a residential environment outside the city but near its resources. (Courtesy of William J. Hayes, 1953.)

This was the site of the Milwaukee Country Club from 1895 to 1911, at the intersection of Downer Avenue and Menlo Boulevard. It was developed in the mid-1920s after completion of paved streets by 1922. Originally the William Marner farm, the country club opened as a riding club and introduced the first golf club in Wisconsin at the turn of the century.

Two Shorewood homes are examples of the wide variety of styles designed by well-known architect Russell Barr Williamson. The concrete block home (above) at 2101 East Newton Avenue, and the Tudor-style home (below) at 2520 East Wood Place, are among over 100 Williamson designs in the Milwaukee area built from the 1920s to the 1950s. Some of his prairie-style homes are mistakenly attributed to Frank Lloyd Wright, with whom Williamson worked in 1916.

Designated a Milwaukee County Landmark, the Annason Apartments at 2121 East Capitol Drive were built in 1930. The 60-unit building was designed by architect Julius Leiser in the Art Deco style, featuring stylized green sunbursts over each window facing north. The building was named by the owner, Armin Miller, in honor of his mother, Anna.

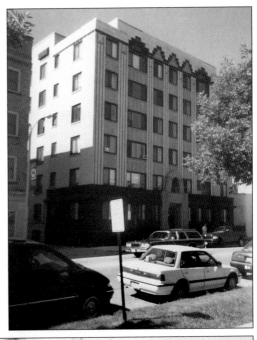

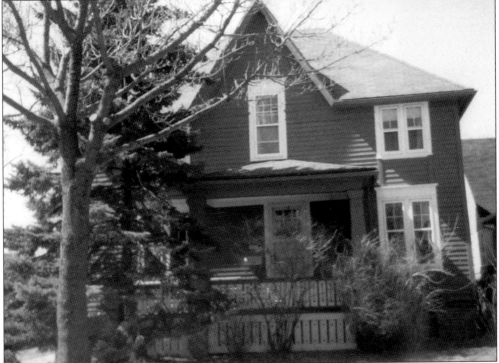

Fred Haselow and his family were the original occupants of this home built in 1900 at 4055 North Stowell Avenue. The property included a small barn, outhouse, and hand pump. A basement cistern stored rain water for washing. The present garage was constructed from the original barn wood. Mr. Haselow was the head groundskeeper at the Milwaukee County Club to the south. He walked to work on wood plank sidewalks.

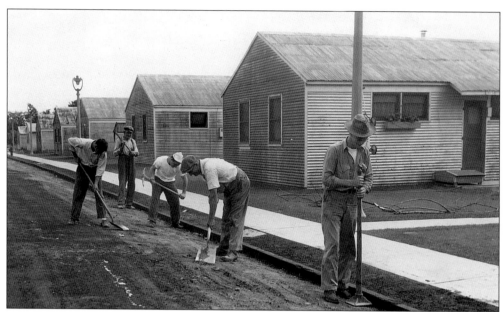

Housing needs for returning World War II veterans prompted Shorewood officials to apply for government aid, which allotted the village 13 two-family metal buildings. The 20-by-54-foot "quonsets" were erected in 1946 along Sherburn Place, just south of the then Pig 'N Whistle. By 1954, the few remaining tenants were asked to vacate, and the property was sold for private development. (Courtesy of Milton H. Abram II, summer of 1949.)

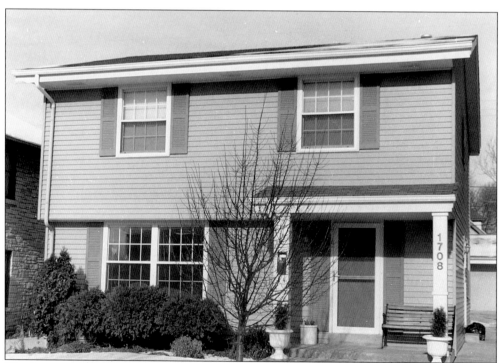

The last single-family home built in Shorewood was completed in 1991 at 1708 East Olive Street. The two-story Colonial house is tucked into a 41-foot-wide lot, extending 132 feet deep.

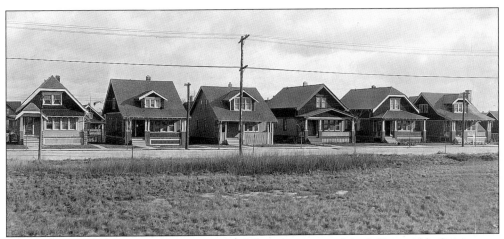

A tidy row of typical Milwaukee bungalows (above, courtesy of A. J. Breitwish), facing west, stretched along Oakland Avenue from Capitol Drive to Shorewood Boulevard from the late 1930s to the late 1960s. In 1968, the 4.35-acre area was purchased by the village, and the buildings were razed. In 1985, construction began for the Eastwood Condominiums (pictured below).

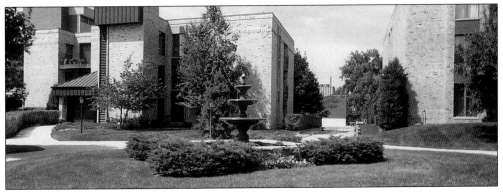

Pictured here is the central courtyard, with fountain, at the Eastwood Condominiums.

When the Shorewood Hospital (above right) was built on East Edgewood Avenue in 1904, the street was unpaved and named Keefe Avenue. As services expanded to treat psychiatric patients, additions were made to the original building, and homes in the block were purchased for staff housing. Columbia Hospital purchased the facility and property in 1969. It was sold to the village in 1997 for residential development.

The final 20th-century residential construction in Shorewood began in 1998, with the Edgewood Condominium development on the site of the former Shorewood Hospital. Encompassing an entire block of 3.5 acres and bordered by East Edgewood Avenue, North Maryland Avenue, North Prospect Avenue, and East Stratford Court, the 13 buildings include 37 units of two- and three-bedroom homes.

Four

EDUCATION: A VISION FOR A PROGRESSIVE SYSTEM

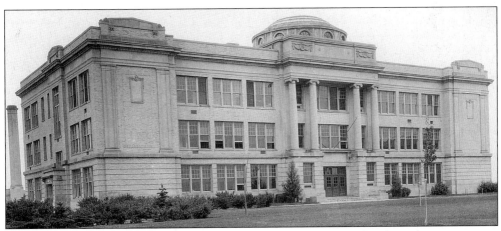

The copper-domed Administration Building of Shorewood High School stands atop a rise on Capitol Drive as the symbol of a school system that means commitment to quality and progressive education. It occupies the same site as the first community school, a log cabin, built in 1848 and destroyed by fires in 1864 and 1895. In 1924, with the completion of the Administration Building, the high school campus plan was under way.

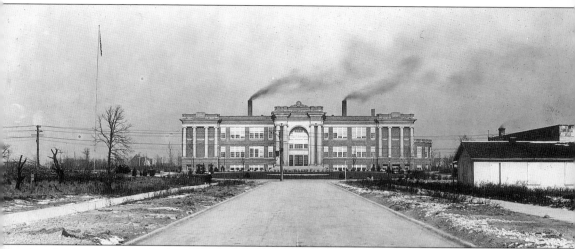

Looking north on Frederick Avenue is a view of the newly completed Atwater School in 1919. Construction of homes in Shorewood from 1900 to 1930 caused a boom in school building construction. The school board purchased a seven-acre tract on Atwater Road, now Capitol Drive, in 1913. The four-room Murray Avenue elementary school (now the Village Hall), built in 1908, was bursting at the seams by 1914. With nearly 200 students enrolled, construction began on the Georgian-style building to be called Atwater School. The front half, containing 11 rooms, was finished and ready for classes September 7, 1915. The back half was completed in 1919, with 11 more classrooms and an auditorium-gymnasium. Note the undeveloped areas around the school and on Frederick Avenue.

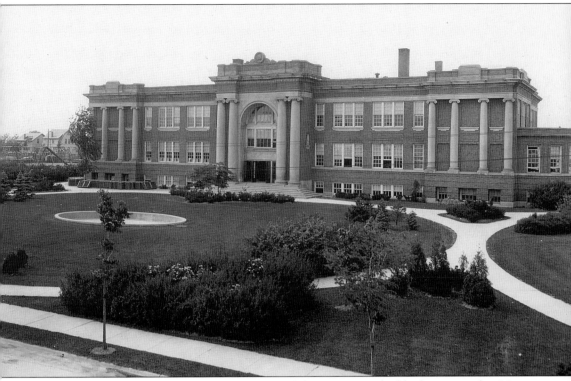

By 1925, Atwater School was fully landscaped, and the community had built up around it. Note the surrounding neighborhoods to the west and north and the fountain on the Capitol Drive side of the school. The original student body was kindergarten through eighth grade. High school students went to Riverside High School with tuition paid by the village. In 1921, the ninth grade was added to Atwater. This group remained at Atwater until the high school was completed in 1925. It became the first class to graduate from Shorewood High School in 1925. Atwater School was designed by architect Walter Judell, a Shorewood resident. (Courtesy of A.J. Breitwish.)

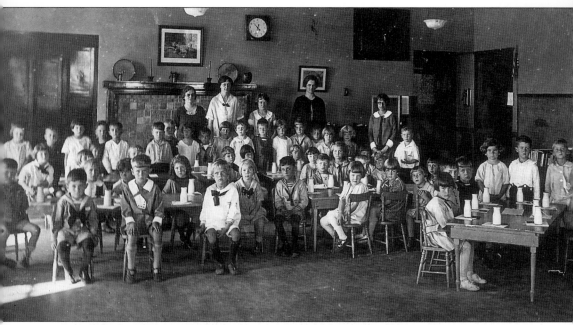

Shorewood was among the first school districts in the state to have both four- and five-year kindergartens. Here is a typical classroom, *c.* 1924. Fran Ruez Buelow (center, second row, girl with dark hair and partially hidden) and Maude Pfeifer Nagle (swiveled in chair, second from left at second table from right) are still village residents. The teachers in the back row are, from left to right, as follows: Miss Ruka, Miss McCoy, an unidentified teacher, Principal Laura Kellar, and an unidentified teacher. Fran Buelow thinks that the K4 and K5 students were assembled together for this picture.

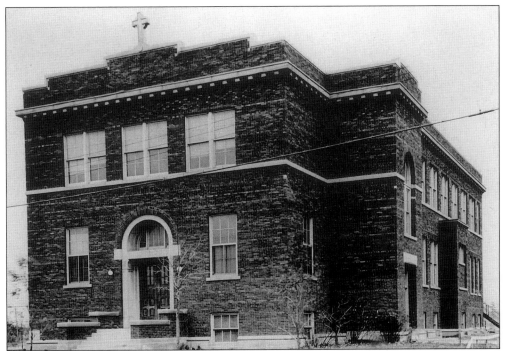

While the public school system expanded, St. Robert's Catholic Church began a school system as well. St. Robert's Elementary School was opened in the church-school building in 1915. Two Sinsinawa Dominican teachers in four grades with 43 students began the school, with a new grade added each year until the first eighth grade class was graduated in 1920.

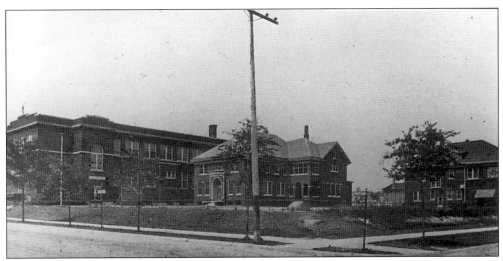

Three classrooms were added to the school system with the construction of the convent in 1924, and in 1927, a major addition of eight classrooms was built to accommodate the large growth in enrollment. (Courtesy of Harry Norton Collection.)

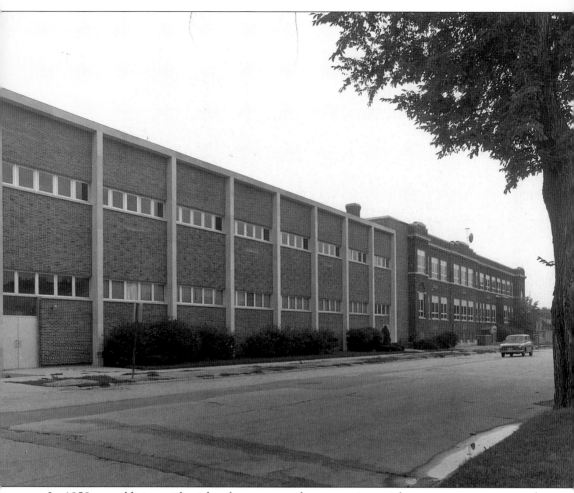

In 1958, an addition with eight classrooms and a gymnasium with a stage was constructed. Kindergartens were initiated in 1983, and in 1987, a Spanish language teacher and a counselor were added to the faculty. From the 1920s to the early 1980s, seventh and eighth graders went to Shorewood High School, and later the Shorewood Intermediate School, to study home economics, mechanical drawing, woodworking, and arts and crafts. In 1955, the congregation contributed $300,000 towards the building of Dominican High School in Whitefish Bay.

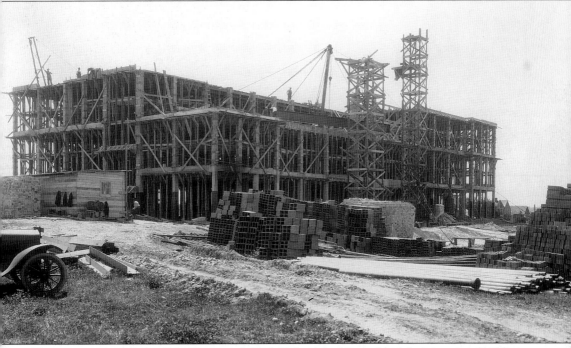

The construction of the first Shorewood High School building, the Administration Building, began in 1924. The school board consulted educators from highly regarded secondary schools, colleges, and universities nationwide. Professor Thomas Lloyd Jones, chairman of the University of Wisconsin High School Relations Committee, recommended a campus plan. He regarded the plan as less expensive initially, and it would allow for expansion as needed. The architectural firm of Herbst and Kuenzli drew the plans for the high school, including drawings of the campus concept. The plans were for a three-story administration building to stand on a slight knoll set back from Atwater Road (now Capitol Drive). There were classrooms for the junior and senior high schools, study halls, and a library, as well as offices for the superintendent, principal, and teachers. The seventh and eighth graders remained at the high school until the construction of the Intermediate School in 1970. (Courtesy of G. A. Brackett, August 13, 1924.)

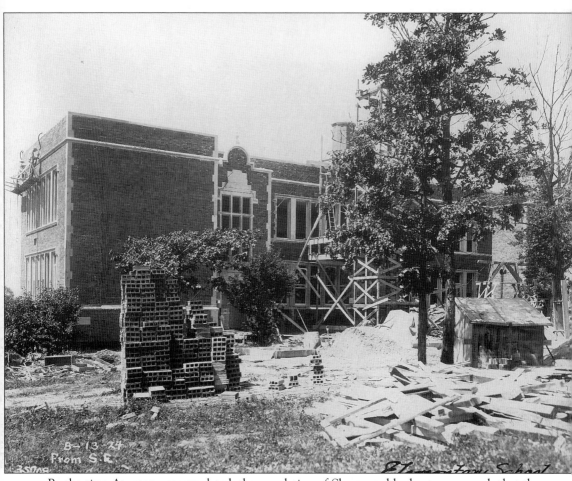

By the time Atwater was completed, the population of Shorewood had grown so much that the school was holding classes in the corridor, the Arnold Hall balcony, and in the basement. The purchase of 19 acres of land at Capitol Drive and Oakland Avenue was the first step towards a new facility and began the process of removing the high school students from the school. However, recognizing the need for another elementary school, the electorate voted for a new school in March 1924. The first portion of Lake Bluff School opened in September 1924. Architects Eschweiler and Eschweiler created the "Old English" or "Domestic Elizabethan" style, which was maintained with each of the original additions. Pictured is the original portion of the building under construction as it faces Bartlett Avenue. (Courtesy of A. J. Brackett, August 13, 1924.)

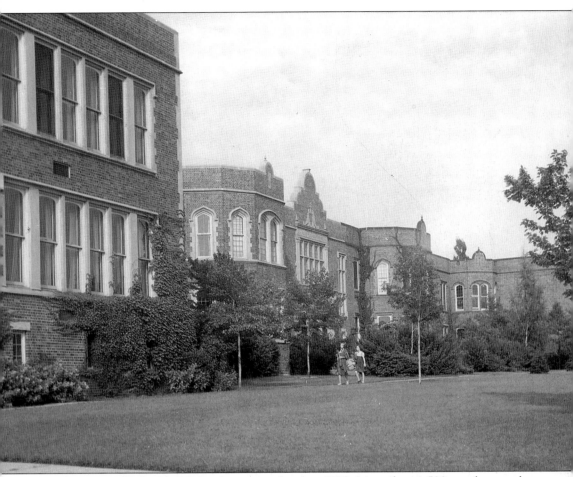

The main wing of Lake Bluff School was completed in 1930. More than 1,500 people turned out to see the 14 new classrooms, little theater, gym, library, music rooms, health suite, and science rooms. Individual rooms were named for Solomon Juneau, Admiral Richard Byrd, Louis Pasteur, Charles Lindbergh, and W.C. Sticher, a pioneer in local health services. The two kindergartens were named for Patty Smith Hill and Mrs. Carl Schurz, founders of the kindergarten movement in the United States. A third addition was built in 1932. By 1939, the school had grown to 33 classrooms, with 675 students from kindergarten through sixth grade. Kindergarten buildings were added to each elementary school in 1970. Major remodeling of both elementary buildings occurred in 1993.

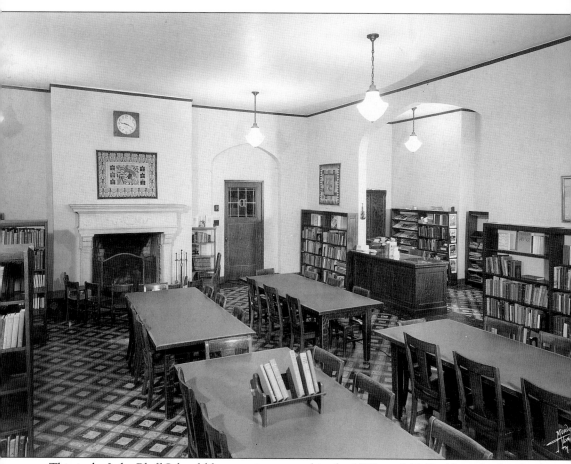

This is the Lake Bluff School library as it appeared in the 1930s and 1940s. Note the fireplace and the reading circle around it. (Courtesy of Murdoch.)

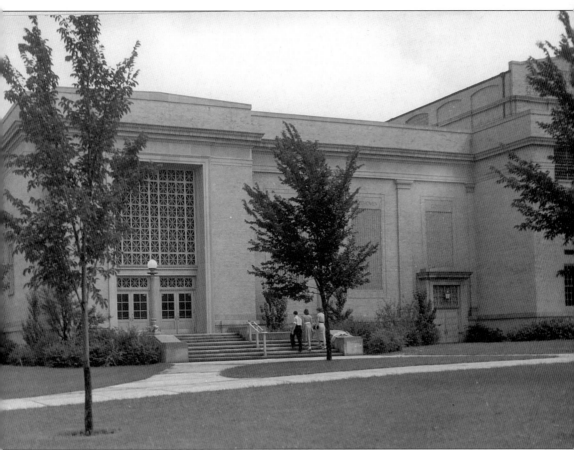

A very special component of the high school campus is the Auditorium Building. WPA funding, as well as a bond issue, made its completion possible in 1935. In addition to the auditorium, there are classrooms, orchestra and band rehearsal rooms, and a little theater. The auditorium is patterned after the RKO Theater in New York City. The acoustics, lighting, and stage design are ideal. It was, and still is, a community facility as well as a part of the school system. The Travel and Adventure Series, North Shore Community Concerts, Shorewood Players, and North Shore Children's Theater are just a few of the organizations that have utilized this facility. The high school drama department has always been an outstanding part of the school system, and it has achieved national and even international recognition for musicals presented in the bandshell at Humboldt Park, presentations at national drama conventions, and an appearance at the Edinburgh Festival in Scotland in 1999.

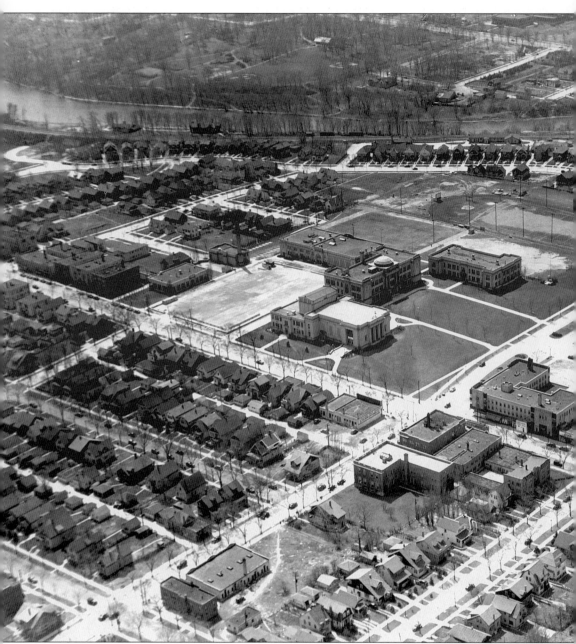

The high school campus concept is best observed in this aerial photograph from the 1930s. It shows the Administration and Manual Arts Buildings, completed in 1925; the Physical Education Building, North Gym, and heating plant, all completed in 1928; the Science Building, completed in 1929; and the Auditorium Building, completed in 1935. School subjects, staffs, and facilities were grouped together to enhance the various learning environments. Particularly note the undeveloped areas west of the Milwaukee River.

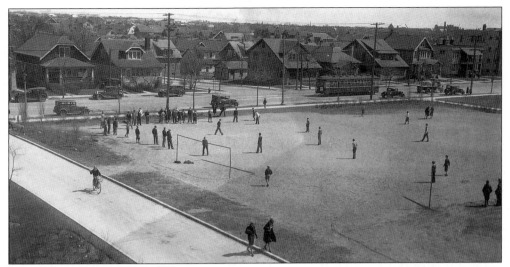

Before the automobile became a dominant part of suburban life, the area that is now the high school parking lot was a play area for physical education classes. This picture was taken in the 1930s. Note the trolley on Oakland Avenue, the cars, and the bungalows where the Eastwood Condominiums are now located.

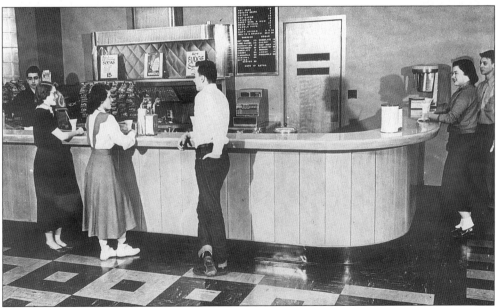

The Youth Center, pictured here in 1957, was completed in 1951 as a part of the building of the new gymnasium. It has been a focal point of social and recreational activities, serving ice cream, popcorn, and other snacks. A unique aspect of the Youth Center is its bowling alley. It also had a jukebox and facilities for shuffleboard and table tennis.

One of the many outstanding features of Shorewood was its Opportunity School. Founded in 1922 by Harvey Genskow, it was a unique way for Shorewood residents to utilize their spare time in a constructive and enjoyable way. The Sunday afternoon Travel and Adventure Series was part of this program. The Opportunity School also sponsored the Shorewood Players theater organization. The North Shore Children's Theater was popular with children on Saturday afternoons. Evening classes included languages, textile and china painting, sewing, photography, commercial subjects, and physical education. In 1970, the Milwaukee Area Technical College absorbed the Opportunity School with state reorganization of vocational education. A Copperdome high school yearbook ad read: "Shorewood Opportunity School . . . Now Come to the LIGHTED School." The Opportunity School used the high school campus.

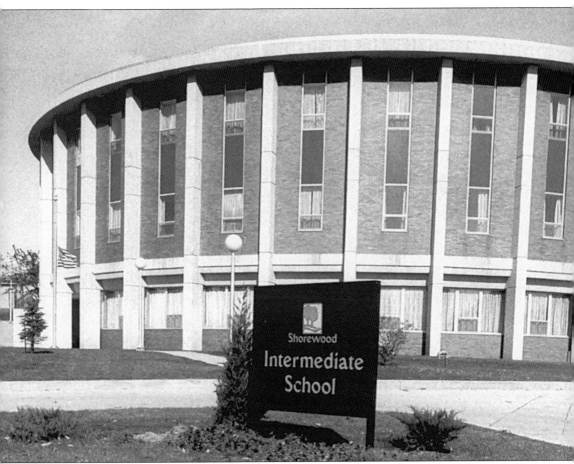

The Shorewood Intermediate School was built in 1970, after the enrollment in the 7th through 12th grade high school and elementary schools increased, and expanded curriculum and staff created a need for more room. Several alternatives were considered, including additions to the high school and elementary schools and a separate school for grades sixth through eighth. A referendum for the grade sixth through eighth school failed on June 6, 1967. A revised proposal for a grades seventh through eighth building and separate kindergarten buildings at each of the elementary schools passed on June 2, 1968. Robert Kupfer, a junior high school teacher who had worked on the second proposal, was the first Intermediate School principal.

Pictured here is the corner of Oakland Avenue and Capitol Drive in 1924, on the morning the steam shovel moved in to begin excavation for the Administration Building of Shorewood High School.

Pictured here is the corner of Oakland Avenue and Capitol Drive as it appears today.

Five

HOUSES OF WORSHIP

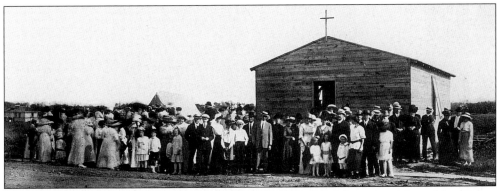

On July 6, 1913, 150 persons were in attendance when the first Mass was celebrated in the new St. Robert Parish. The parishioners worshiped, until October 1913, in a small temporary wooden church built on the unused right of way of the abandoned "Dummy Line" on the south side of Mineral Spring Road (Capitol Drive) at Maryland Avenue.

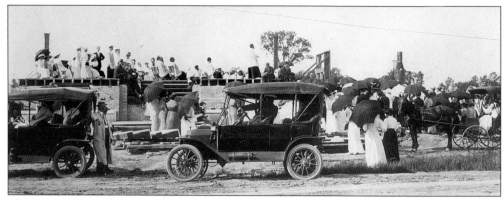

The cornerstone of the St. Robert Church and School building was laid on July 27, 1913. Parishioners arrived in autos and buggies to take part in the ceremony. The building was constructed on the north side of the road across from the temporary wooden church.

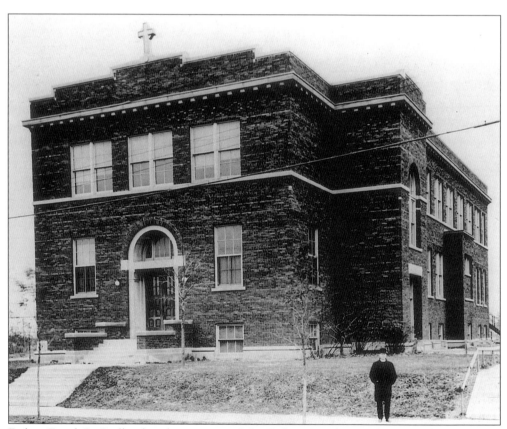

Father Farrel P. Reilly, founding pastor of St. Robert Parish, stands in front of the first permanent church/school building on Mineral Spring Road (now the corner of Capitol Drive and Maryland Avenue).

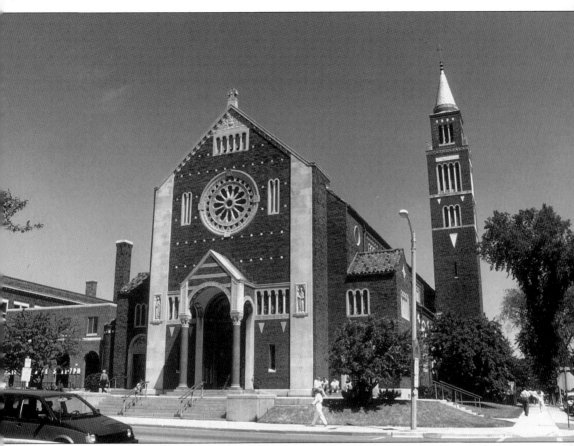

In this late 1980s John P. Otis photo, the St. Robert Parish campus is viewed from the corner of Capitol Drive and Farwell Avenue. Included are the following, from left to right: the school (the first permanent structure, built in 1913), the Parish Center (former convent, 1924), and the church (1936–1937). A rectory-parish office building (1917) is on Farwell Avenue. The school, convent, and rectory have had several additions since the original construction.

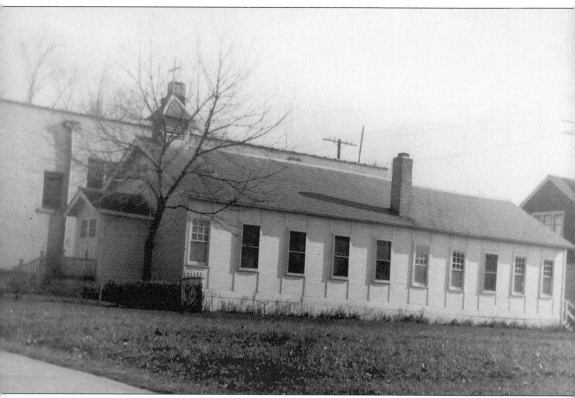

The Mission Board of the Wisconsin District of the Missouri Synod of the Lutheran Church erected a wooden one-story chapel on Capitol Drive next to the Telephone Exchange Building. The congregation found the building adequate in the summer, but there was no provision for heating in the winter. The growing congregation purchased three lots at the southwest corner of Maryland Avenue and Shorewood Boulevard. The chapel was moved to the new site after a basement was excavated for a furnace in 1917.

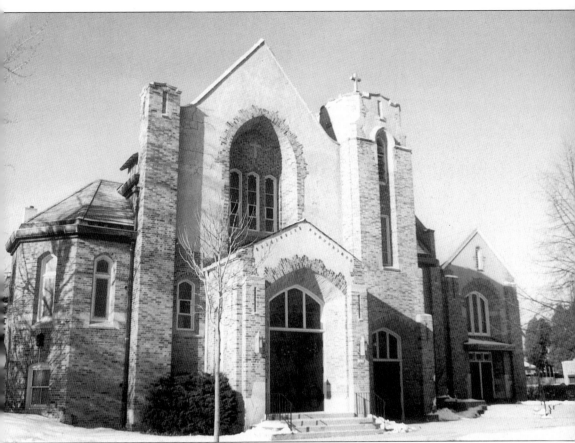

Continued growth of the congregation led them to commission the architectural firm of Brust and Philip to design a new church building, thus replacing the wooden church at the site. When it was dedicated in May of 1925, the congregation had changed its name. Although they had taken the name Evangelical Lutheran Church of East Milwaukee in 1916, the Village of East Milwaukee became the Village of Shorewood in 1917. To celebrate its roots, the congregation then became Luther Memorial Chapel.

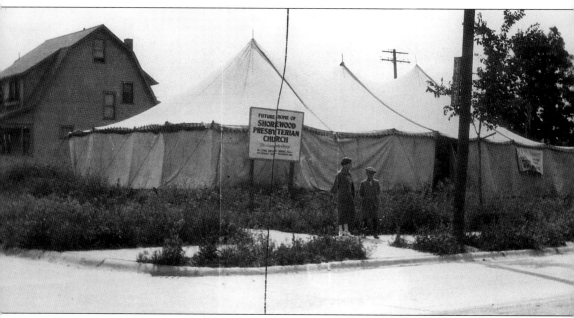

Sunday school classes, organized as a mission of a Presbyterian congregation in the City of Milwaukee, were held in an empty store building on the corner of Capitol Drive and Stowell Avenue. This led to the organization of Shorewood Presbyterian Church on June 16, 1922. Outgrowing the old store, the congregation purchased three lots on the southeast corner of Oakland Avenue and Kenmore Place. The first services, held in a large tent (1923) at the site, were well attended, but the congregation did not appreciate the many mosquitoes. Sunday school classes were held in the storefront church and in an empty jail cell for a time. Children living in the northern part of the village attended classes on the second floor of the Shorewood Theater Building at Oakland Avenue and Lake Bluff Boulevard.

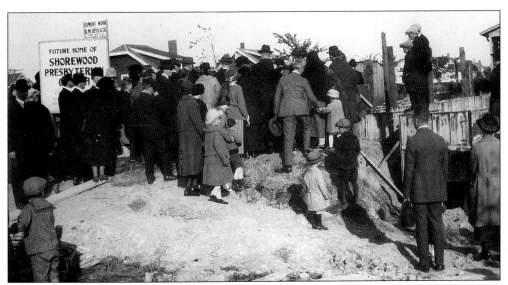

The cornerstone was laid for Shorewood Presbyterian Church on October 10, 1923, and the building was dedicated on March 30, 1924 (pictured above). The 1924 building served the growing congregation well until after World War II, when architects Brielmaier, Grellinger, and Rose were hired to design a new church building. The building on Oakland is now occupied by the Dance Center and the Shorewood Press.

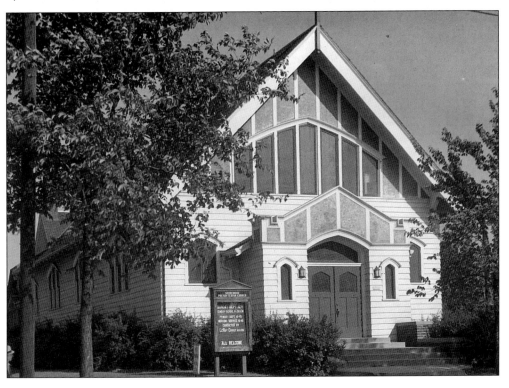

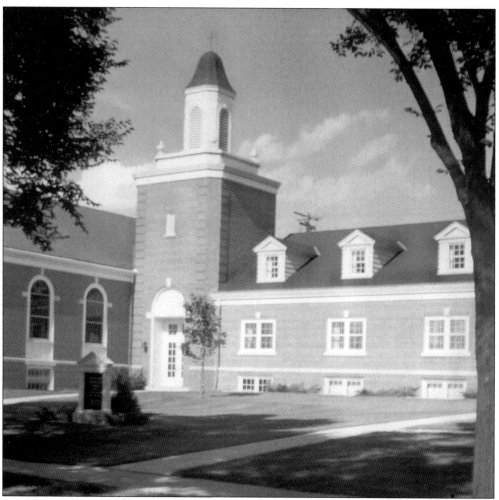

Land was purchased for the new church on the southeast corner of Bartlett Avenue and Kenmore Place. Upon the dedication of the new red brick Colonial-style edifice on March 3, 1952, the congregation became North Shore Presbyterian Church in recognition of the wider area served. A Christian Education wing was added in 1959.

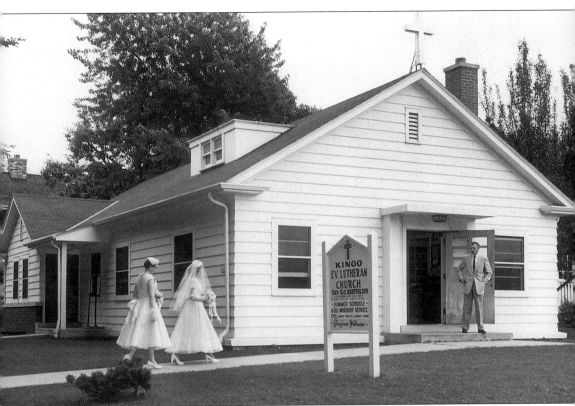

Forty people met in a home in the City of Milwaukee in 1909 to organize a Danish Lutheran Church. For several years, they met in a vacant church building at Hubbard Street and Meinecke Avenue and were served on a part-time basis by a pastor from Hartland, Wisconsin. A full-time pastor was called in 1913, but it was not until 1927 that the congregation voted to adopt the name of Thomas H. Kingo, an 18th-century Danish Lutheran pastor whose hymns were well known to the congregation. With a focus on the future, the congregation began a building fund in 1944 that was used to purchase land at the corner of Olive Street and Wilson Drive. A frame chapel was dedicated in March of 1951. In this picture, a bride and her bridesmaid are seen approaching the church. (Courtesy of Clair J. Wilson.)

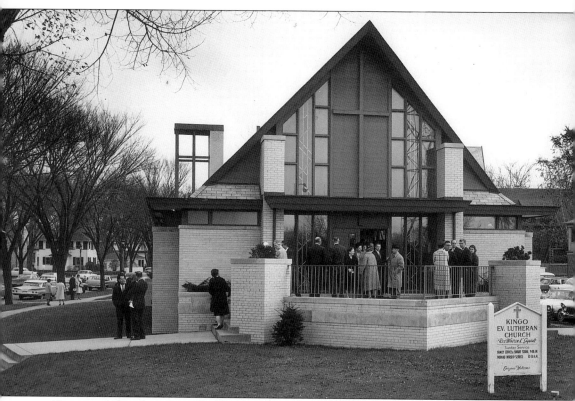

Kingo used the white frame building as a church until 1958, when a tan brick church building was completed. The original chapel was then linked to the new church to be used for Christian education classes. Pictured here is the new church with members of the congregation gathered on the entry decking. In recent years, a new approach to the entry has been constructed. (Courtesy of Clair J. Wilson.)

Six

GOODS AND SERVICES: FROM SALOONS TO SALONS

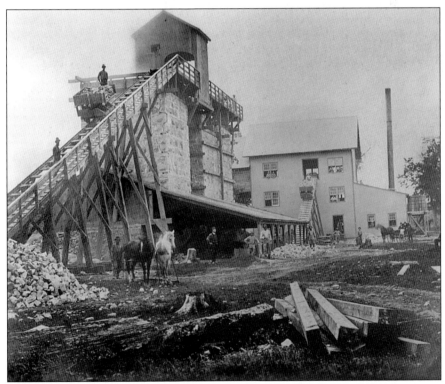

Cement mills operated from 1876 to 1909 on the Milwaukee River north of Capitol Drive and produced 4,000 barrels of cement per day at their peak. The cement was mostly used for local construction, but some was shipped to Sault Ste. Marie for the first Soo locks. The limestone layer along the Milwaukee River provided the raw material for the mills. The area was known as Cementville early on.

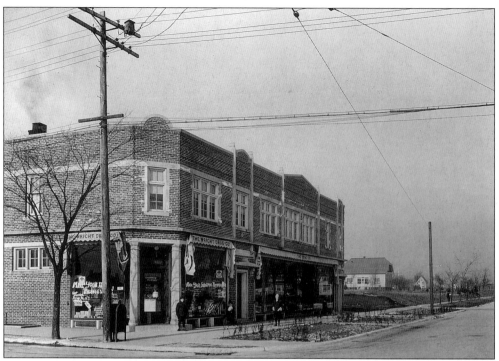

One of the oldest retail buildings in Shorewood is Hayek Pharmacy on the northwest corner of Capitol Drive and Downer Avenue. Constructed in 1916, it was originally home to the Wright Drugstore, Gahn Meat Market, and Van Alstine's Grocery. Note the vacant land to the north of the building in this 1916 photo.

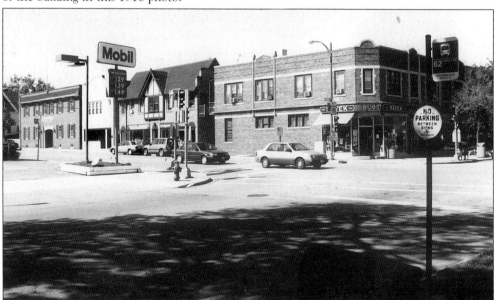

The Hayek Pharmacy building has changed little since it was constructed. The pharmacy currently occupies the entire first floor of the building, and the second floor is devoted to office space and apartments as it was in the past. The area surrounding Hayek's is completely developed.

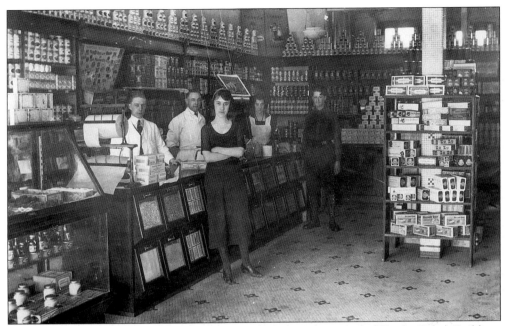

Van Alstine's Grocery was located in the north half of the Hayek (Wright Drug) Building. Many items were sold in bulk. The customer told the proprietor what she or he wanted, and he went to fetch it, wrapped it in white paper, and tied it with store string. Before mechanical refrigeration, many perishables had to be purchased daily.

The store building on the southwest corner of Capitol Drive and Prospect Avenue has been occupied by many floral shops, including Jasculca's, Jim Manders—the Shorewood Florist, Gernette-Kamrath Floral, and Kamrath Studio. It also housed a meat market and art gallery. At the present time, a pet supply store—Wisconsin K-9 Center—occupies the store space, and apartments occupy the second floor. (Courtesy of G.A. Brackett.)

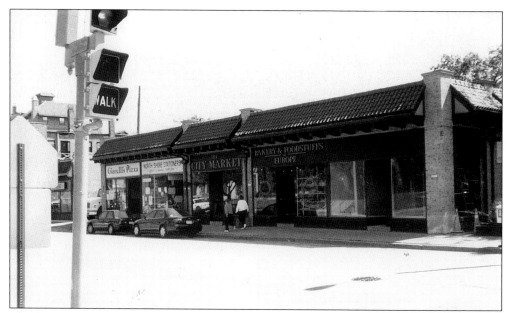

The business block across the street from St. Robert Church was constructed prior to 1925. Located between Farwell and Maryland Avenues, its tenants over the years have included hardware stores, groceries, drugstores, restaurants, gift shops, bakeries, florists, meat markets, physicians' offices, architects' offices, office supply stores, pizzerias, resale shops, and children's clothing stores. The Shorewood Public Library occupied two storefronts from 1953 to 1965, both of which now house City Market.

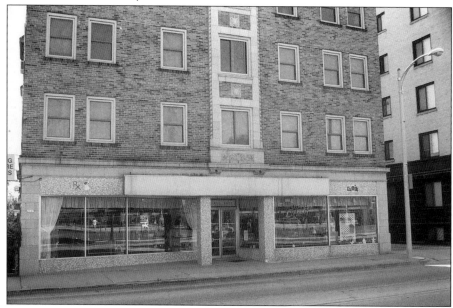

The Morrison Apartments, at the southwest corner of Capitol Drive and Maryland Avenue, are typical of many with first floor retail spaces. The building was occupied for years by Shore Drug Company (later Shore Drug and Camera). Prescription and camera symbols remain in mosaic above the doorway. A Kiddie Kampus clothing store once occupied the western half. Now it is the Clothes Caddy resale shop. Owner Armin Miller named the building for his father, Morris.

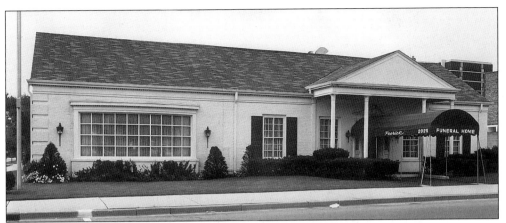

The Feerick Funeral Home has been located at 2025 East Capitol Drive since 1933, when the business was moved from a North Avenue location to its new site. A 1965 purchase and subsequent removal of homes allowed for parking and expansion of the building. Founded in 1896, the business is in its fourth generation of family ownership.

Constructed in 1953 as home for the American Bowling Congress, this building, on the northwest corner of Capitol Drive and Bartlett Avenue, was purchased in 1971 by Catholic Family Life Insurance Company for use as its national headquarters. Founded in Milwaukee in 1868, it is the oldest Catholic benefit society in the United States.

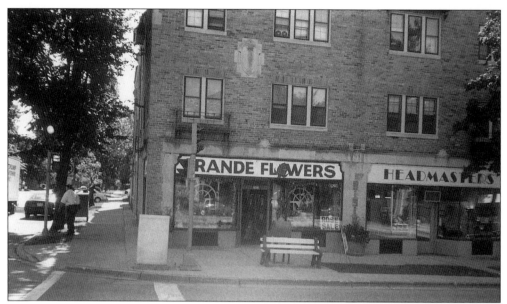

Located on the southwest corner of Capitol Drive and Morris Boulevard, this beautiful Mediterranean-style apartment building is another with first-floor retail space. It is now the home of Grande Flowers and Headmasters Salon. For years, the flower shop unit was occupied by Jean Fontaine Junior Footwear, which featured a unique square-heeled children's shoe known as the "Jumping Jack."

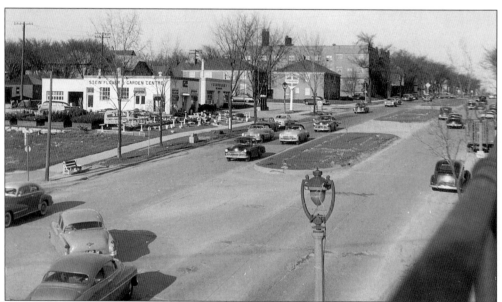

Stein Flower and Garden Center, the original store from which the large retail chain of Stein Garden and Gifts has grown, occupied the northeast corner of Capitol Drive and Wilson Drive in this 1950s photo. Note the concrete-framed bus stop bench and the absence of traffic signals. The streets are lighted with signature Milwaukee harp lights. A Mobil gas station and an apartment building now occupy the area.

The south side of Capitol Drive between Woodburn Street and the railroad tracks has sustained many changes. The Ehlers Buick dealership, substantially remodeled, houses the Palette Shop. Bakers Square Restaurant has replaced the Forrer Specialty Company. A miniature golf course and a Christmas tree lot were once located in the same place, and tucked in behind was a *Milwaukee Sentinel* substation, where carriers picked up early morning papers.

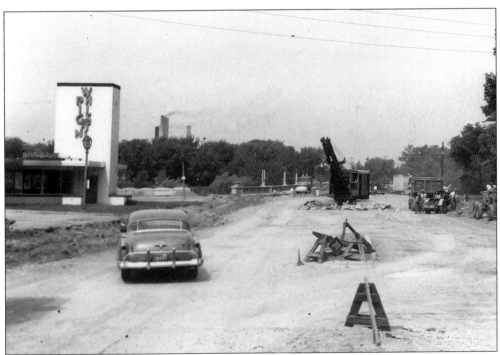

On the south side of Capitol Drive, between the railroad trestle and the Milwaukee River, the Pig 'N Whistle was a Shorewood institution from 1938 until the late 1980s. A small drive-in custard stand, "The Pig" grew to be a popular family restaurant. New owners moved the business and ceased operations shortly thereafter. At the same site is the new Riverbrook Restaurant. (Capitol Drive under reconstruction, late 1940s.)

79

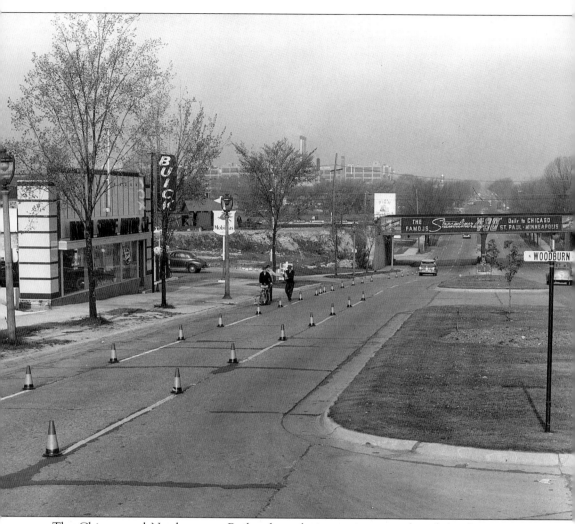

The Chicago and Northwestern Railroad trestle is prominent in this photo facing west on Capitol Drive. It advertises "The Famous Streamliner 400, Daily to Chicago–St. Paul –Minneapolis." The "400" made the trip from Chicago to Minneapolis in 400 minutes. The railroad right-of-way is now a bicycle path, and the trestle is painted Shorewood Blue and is used to advertise village events such as Shorewood Players productions, St. Robert Fair, and the Men's Club Chicken Barbecue. The huge buildings in the left background made up the American Motors body plant. The plant was closed many years ago, and a business district has been organized. A Jewel-Osco store occupies part of the space facing Capitol Drive. This photograph dates back to the spring of 1949.

The northeast corner of the Oakland and Edgewood Avenues intersection contained a gasoline station for years. In 1969, the Humble Oil Company gave the property to the village as a park with the proviso that it be called Humble Park. The building to the north (left) held the office and presses for the *Shorewood Herald* for many years. The upper floor was occupied by athletic supplier the Steve Tojek Company.

The Fass Funeral Home, on the northwest corner of Menlo Boulevard and Oakland Avenue, has been a village landmark since 1931. It is a classic Mediterranean building, an architectural style which was extremely popular when Shorewood experienced its greatest growth. In recent years, under new ownership, the name was changed to Fass Balistreri.

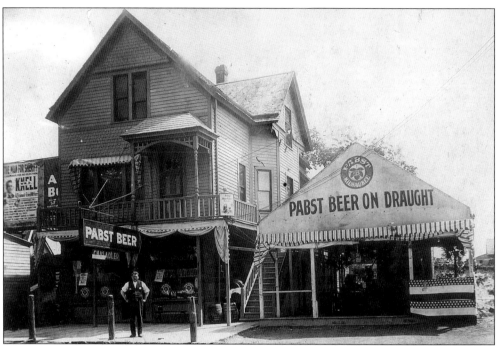

Charlie Adler's tavern (above in 1914) was a popular watering hole at the turn of the century. Located on Oakland Avenue, just south of Newton Avenue, it was almost directly across the street from the amusement park entrance. Note the hitching posts for horses. The interior photo of Adler's (below in 1903) indicates the lack of bar stools and the inclusion of spittoons for tobacco chewers. Distributors' signs advertise Pabst and Blatz beer, Blatz tonic, and Pabst Kulmbacher. The man behind the bar remains unidentified but presumably is Charlie Adler.

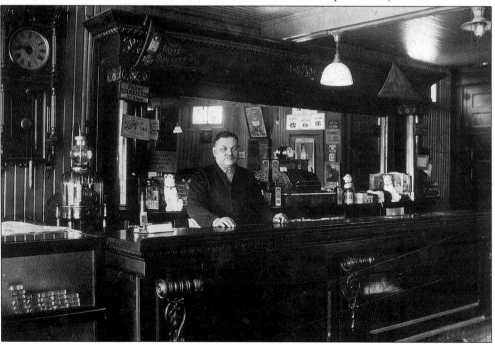

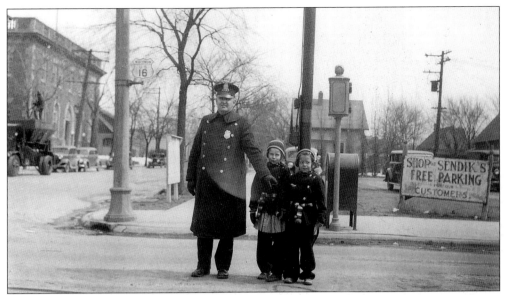

Patrolman Bill Wepfer helps children cross Oakland Avenue at Capitol Drive. At the time the photo was taken, the Sendik Fruit Market was on the southeast corner of this hub of Shorewood commerce. The Telephone Company building is on the left in the picture. With a new facade added in later years, it is now an Ameritech building. It once housed all the operators needed for the EDgewood, CHurch, and WOodruff exchanges.

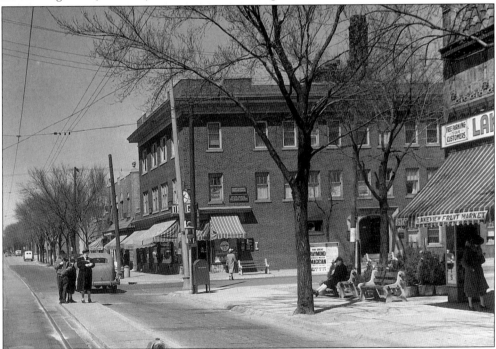

In the 1930s, the Lakeview Fruit Market, predecessor of Sendik Fruit Market, occupied the site that was later home to the Yankee Doodle and Ming Garden restaurants. The North Shore Bank building (formerly Badger Bank) is on that property now. A&P and Imse groceries were also located at this site.

Ming Garden (left) occupied the southeast corner of Oakland Avenue and Capitol Drive in the 1960s. South of the restaurant was the Camera Center, and south of that was the headquarters of the North Shore YMCA. Across Oakland Avenue (right) is the Shorewood High School Auditorium. The entire east side of the block was razed in the late 1960s as part of an urban renewal project. Both sides of Cramer Street and the west side of Murray Avenue, 3900 blocks, were also leveled at the same time.

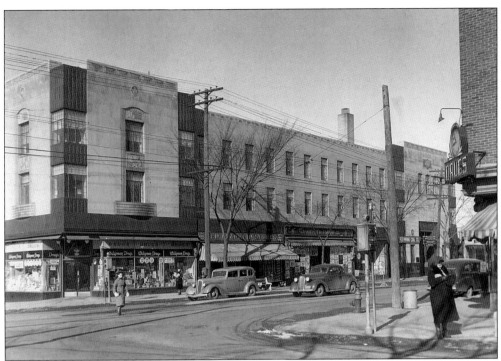

The building on the northwest corner of Capitol Drive and Oakland Avenue is a combination retail and apartment building. Originally called the Armory Court Apartments, it was constructed shortly after the Armory was razed in the early 1930s. Its architecture is Art Deco, a style that reached its peak during the period of Shorewood's greatest growth. The north entrance has always been a bank, currently Norwest. (Courtesy of WPA Federal Writers Project.)

The stylized buffalo nickel and coins in bas-relief above the Norwest Bank entrance are among several designs that embellish the building. The building is listed in the National Register of Historic Places. Harley's men's clothing store has been at this location since 1948. Other businesses included Capitol Drug, a Ben Franklin store, Heineman and Daily's bakeries, a Hallmark shop, and presently a salon—Actaea Works, Ltd.

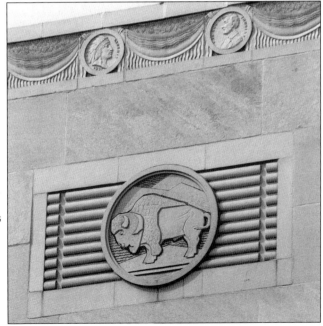

John Palmer, a former Shorewood policeman and village trustee, was proprietor of the Palmer House at 4004 North Oakland Avenue from 1948 to 1964. It was popular for its Sunday morning ham and hard rolls.

Salvatore Balistreri, Anthony Balistreri-Sendik, and Ignatius Balistreri are pictured here outside the Sendik Fruit Market just north of Capitol Drive on the west side of Oakland Avenue. Two of the three brothers later opened stores on Downer Avenue and Silver Spring Drive. Customers asked the immigrant grocers to "send it," which morphed into "sendik," and this later became the name of the stores (and eventually the surname of Anthony and his descendants).

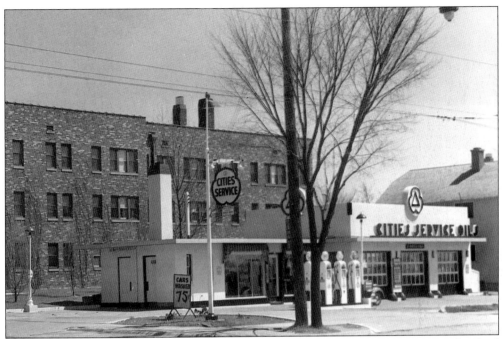

A filling station on the southeast corner of Olive Street and Oakland Avenue is now the Food Affaire restaurant and catering service. At one time, the village had at least 15 gas stations. Also departed are names like Wadhams, Pate, Texaco, Standard, Enco, Spur, Humble, Pure, Conoco, Cities Service, Skelly, and Sinclair.

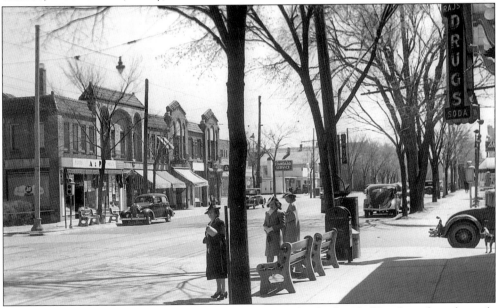

This photo shows the east side of Oakland Avenue, south of Lake Bluff Boulevard, in the early 1930s. The space furthest to the north (left) was an A&P grocery store, which later became Drigget's Sporting Goods, where high school girls purchased the bloomer suits then required for physical education classes. The space to the south has been a bakery for over 40 years. Note the ladies wearing hats waiting for the Number 15 streetcar.

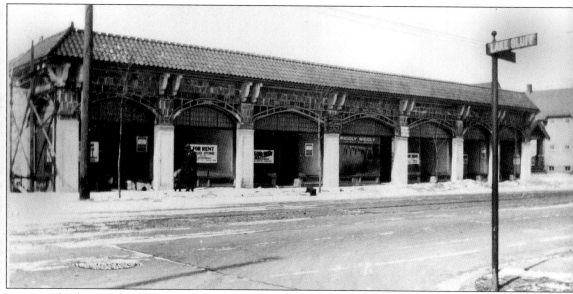

This beautiful building (under construction) on the northwest corner of Oakland Avenue and Lake Bluff Boulevard was designed by noted architect Herbert Tullgren in 1922. It has since housed many quality shops. Rajski Pharmacy was on the corner for many years, and Jorgenson Candy next door produced much-sought-after handmade chocolates. The building has survived the test of time very well, perhaps even more attractive today than when newly constructed. It is home to a number of upscale retail establishments. (Courtesy of Thomas C. Kuehn.)

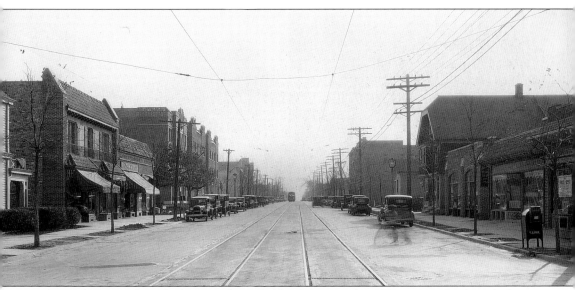

In this early 1930s photo looking south on Oakland Avenue from Kensington Boulevard, the double streetcar tracks and electric wires overhead, the harp street lights, and the utility poles curbside can be seen. Most of the buildings on the east side of the street (left) are still intact, while most of those on the west side (right) have since been demolished.

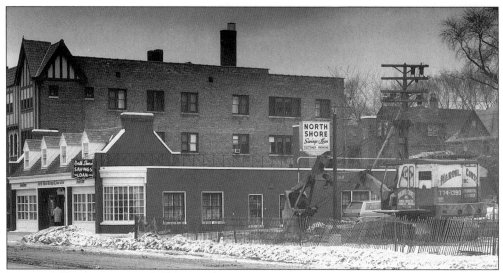

The first home of the North Shore Savings and Loan Association, now known as the North Shore Bank, was located just north of Lake Bluff Boulevard on Oakland Avenue in a one-story building with a partial second floor. This picture (above) was taken during the construction of the new building (pictured in the same location, below). Shorewood banks have always had similar names—the bank in the Armory Court building was originally known as the Shorewood Bank and later became the North Shore Bank. It is now part of the Norwest system. North Shore Savings and Loan became North Shore Bank after the savings and loan law changed in the early 1990s. The North Shore Bank on the southeast corner of Capitol Drive and Oakland Avenue was originally the Badger Bank.

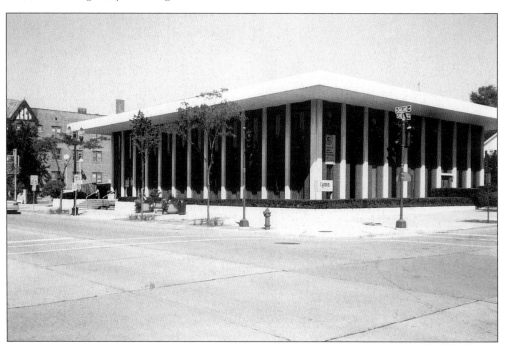

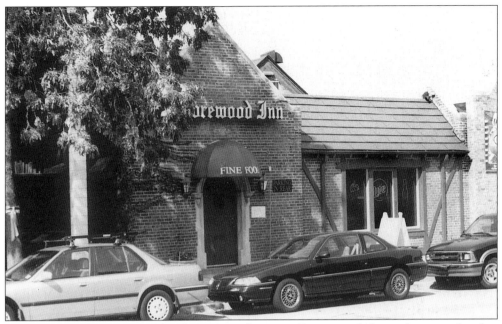

The Shorewood Inn, a popular dining spot for over 40 years, inhabits a location that has always housed a restaurant. Briefly, in the early 1990s, it was Manning's. It was opened as Keller's Inn in October of 1933 and is located on the west side of Oakland Avenue south of Kensington Boulevard.

Significant because of its beauty, this retail outlet has had many tenants over the years, but has managed to retain its original facade. It may be the only remaining Art Deco storefront in Milwaukee County.

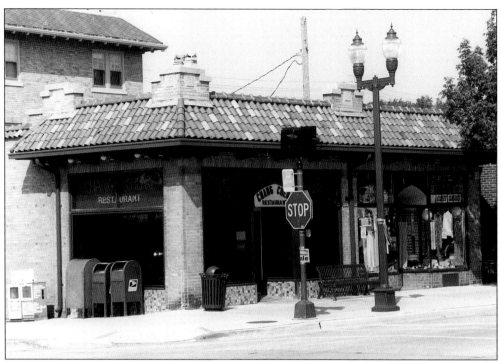

Now Chang Cheng restaurant, this space on the northwest corner of Oakland Avenue and Kensington Boulevard was occupied for years by Wiesner's Delicatessen, offering bagels, blintzes, and liver pate.

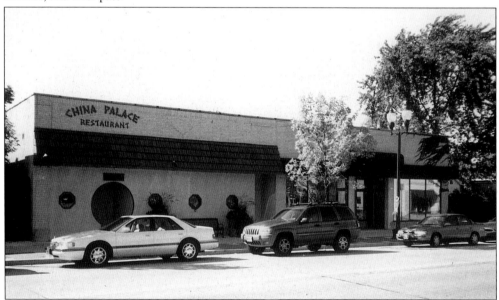

A few doors north of Kensington Boulevard, on the west side of Oakland Avenue, stands this large building, one of the area's first grocery supermarkets. Currently divided into China Palace restaurant and two retail establishments, it was the home of Bay Shore Hardware for years and, later, Stevenson's Office Supply. At one time, the village had two hardware stores, with another just south of Edgewood Avenue on Oakland Avenue.

Seven

HAVING FUN FROM RIVER BANK TO LAKE SHORE

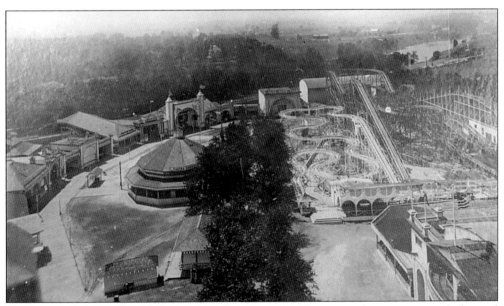

Ravenna Park, opened in 1909, was one of a succession of resorts and amusement parks located west of Oakland Avenue at about Menlo Boulevard. It was preceded by Lueddemann's-on-the-River in 1872, which later became Zwietusch's Mineral Springs Park, Coney Island in about 1900, and Wonderland in 1905. Ravenna was eventually closed in 1916, and part of the land was purchased by the Milwaukee Electric Railway and Light Company for use as car barns.

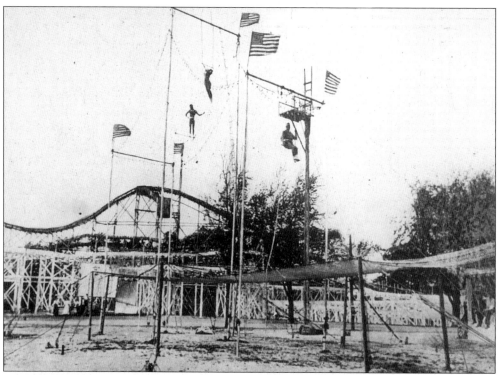

Ravenna, the last of the resorts and amusement parks to be operated on land that is now used for Hubbard Park and River Park Apartments, was opened in 1909 and closed in 1916. Pictured here are the high wire and trapeze artists that performed at the park. The roller coaster is in the background.

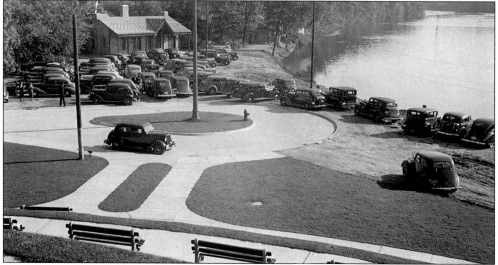

Almost five acres of land along the Milwaukee River now constitutes Hubbard Park, named for a former village president, William J. Hubbard. Earlier, the land had been home to several amusement parks and resorts. It is wooded and terraced, with a few community buildings and parking lots. In this 1935 photo, the skating warming house can be seen in the background and the paved auto turn-around in the foreground.

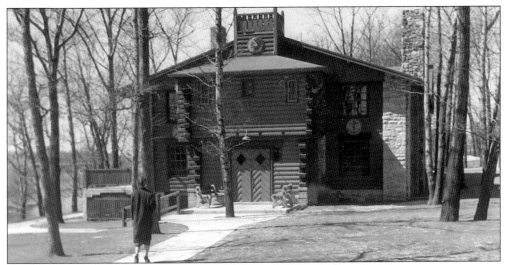

Rustic community buildings erected in the 1930s are available for public use. The Scout Craft Cabin (Hubbard Lodge) is pictured above. It is the building farthest north in the park. In this 1940 picture, the outside deck on the left and the signal tower on the roof are visible. The lodge has been the site of many dances, USO parties, birthday and graduation parties, wedding receptions, and Men's Club dinners.

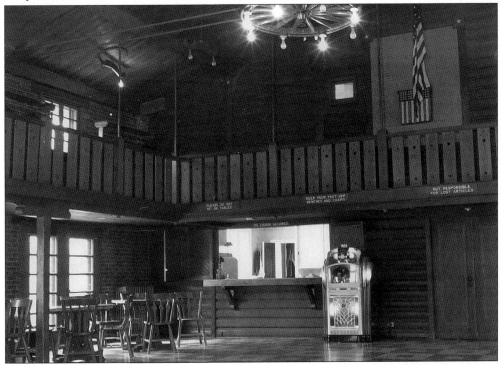

The interior of the Scout Cabin, pictured here in 1941, is bordered by a balcony on three sides. French doors lead to the outdoor deck, and a flagstone fireplace surround rises to the ceiling on the right side (not pictured). A jukebox is the main source of music. Wagon wheel light fixtures add to the rustic atmosphere. In recent years, the interior has been renovated to provide a fine dining atmosphere, and it is known as Hubbard Park Lodge, operated by a private caterer.

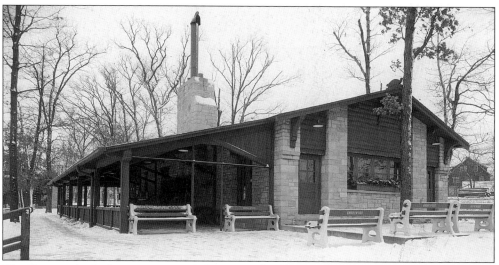

The Community Lodge was commonly known as the Shorewood Woman's Club for nearly half a century, being utilized by the club for meetings and parties until recently, when the group began meeting in the village library. The Woman's Club was organized in 1936.

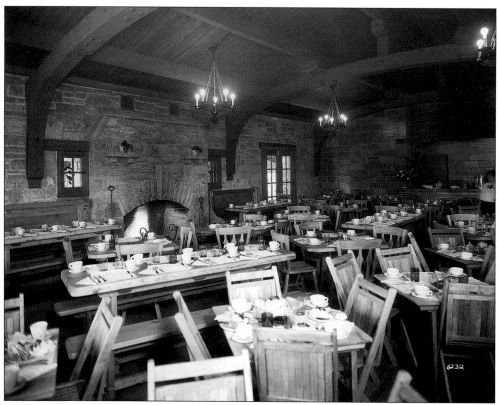

The interior of the Woman's Club building (pictured) was rustic in the style of the other park buildings. It was furnished with picnic bench tables and wooden folding chairs. A stone fireplace complemented the rustic charm. It is now named the River Club. (Courtesy of Henry C. Hengels, village engineer.)

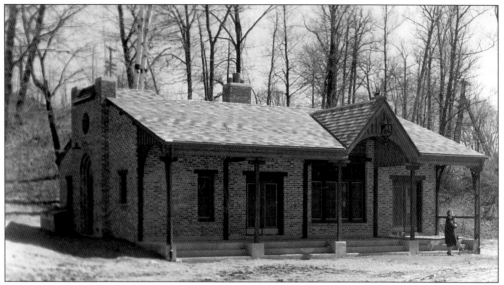

The warming house south of the auto turn-around at Hubbard Park was built to accommodate residents who came to the Milwaukee River to skate in the winter. The building has been used for community gatherings such as scouting events.

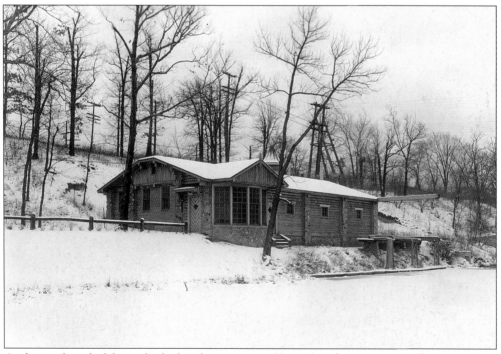

At the south end of the park, the boathouse was used by Milwaukee-Downer College from 1938 until its merger with Lawrence University in the mid-1960s. The Milwaukee Rowing Club used the clubhouse for many years, storing its shells there. In the mid-1990s, the Rowing Club moved down river to the site of the former dam at Commerce Street in Milwaukee. (Postcard.)

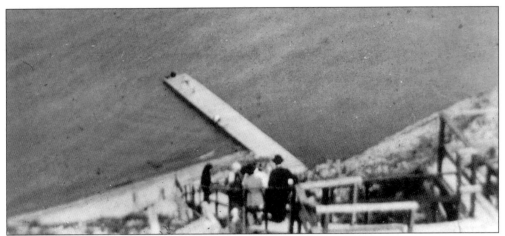

The original Atwater Beach pier (seen here in 1918) was wooden and was reached by descending steep wooden stairs from the top of the bluff in the park area along Lake Drive. A wooden shack with dressing rooms was at the foot of the bluff on the beach. This pier was used from about 1916 until three cement block piers were constructed in 1932.

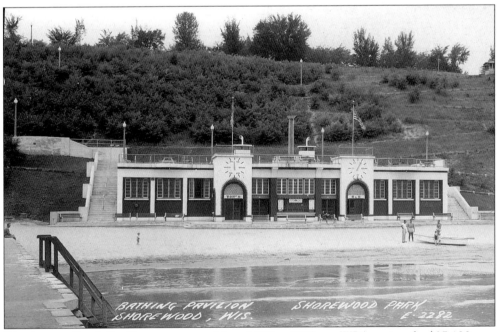

The Atwater Beach Pavilion, constructed from 1937 to 1938 as a WPA project for $37,120, was a popular gathering place for villagers of all ages. Badly deteriorated, with repairs and renovation deemed to be too costly, the pavilion was demolished in 1987. (Postcard.)

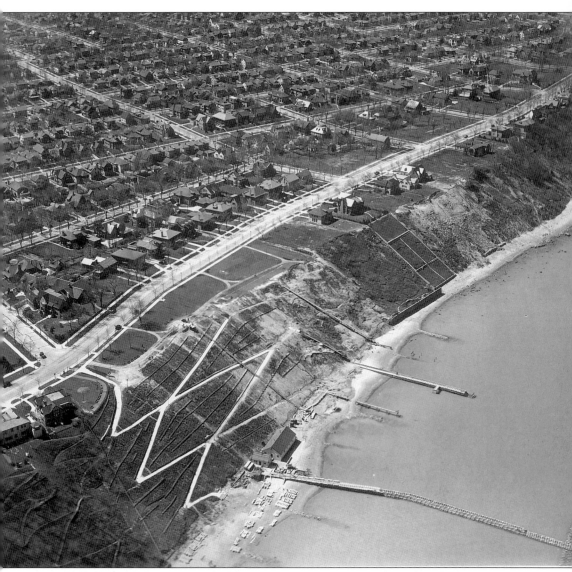

By 1900, the farmsteads of East Milwaukee were giving way to residential areas. Streets were plotted, and business districts began to take shape. Residents valued their open spaces along both Lake Michigan and the Milwaukee River and sought ways to retain these properties for the community. As early as 1916, the village government authorized the construction of a flight of steps to the beach from the little park area at the top of the bluff. The area was named Atwater Beach (Capitol Drive was Atwater Road at that time). A wooden dressing house and wooden pier were constructed at the water's edge. Three jetties (piers) were built out into the lake in 1932, allowing a sandy beach to pile up. In this aerial photo, the main pier with the "T" is prominent. The wooden building on the beach is at the head of the pier. Also noticeable is the zigzag path that afforded beach visitors a less steep, more gradual descent and ascent. (May 15, 1935, from 1,000 feet.)

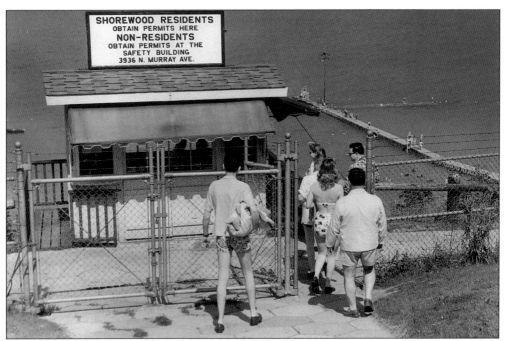

Access to the beach and fishing piers were past this gatehouse. Shorewood residents could get a season permit to the beach; nonresidents needed daily permission from the police to enter. Shorewood families had a permit number that was shouted to the gatekeeper in the house when entering the gate to the switchback paths. (Courtesy of Milton H. Abram II, summer 1947.)

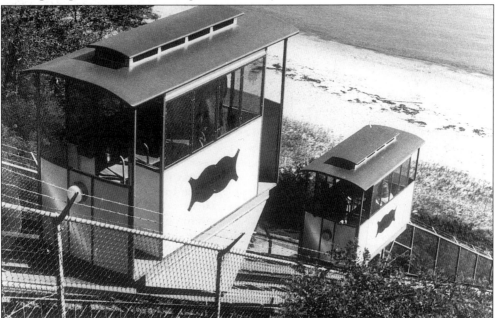

From 1967 to 1977, a pair of cable cars—Able Cable and Twinkle Tow—operated from the bluff to the beach, carrying beachgoers for a dime per ride. A building that sheltered the trams at street level was erected in 1970. In 1987, ten years after the service was discontinued, the tracks were removed.

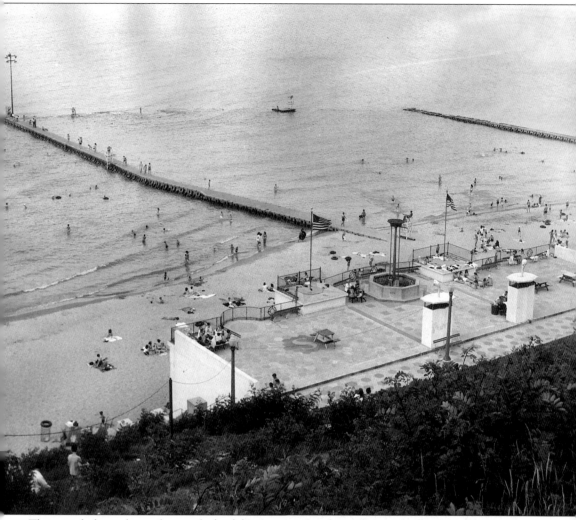

This aerial photo shows the top deck of the Atwater Beach pavilion and two of the three piers. The center pier at the far end, with its wings, was known as the "T." Between each of the piers were rafts at the depth of the end of the center pier. Lifeguards on high chairs on the beach and on the piers and rafts were usually Shorewood High School student swimmers. A concession stand was in the beach level of the pavilion, along with men's and women's dressing rooms and showers. The flooring of the pavilion top was tile; a Shorewood "S," fashioned in tile, can be seen in this picture. Picnic tables were provided, and on a hot summer day, the tables and platforms supporting the American flags were the favorite sunning spots for high school girls and boys. (Courtesy of Milton H. Abram II, summer 1947.)

Atwater Park, set aside by the village for the enjoyment of residents in 1916, currently attracts the community with a children's play area, benches placed to enjoy the lake view, a deck, and wide steps (shown below) leading down to the beach. The switchback walks still provide an alternate route. During warm weather, the park is the scene of band concerts and the annual Shorewood Men's Club Chicken Barbecue.

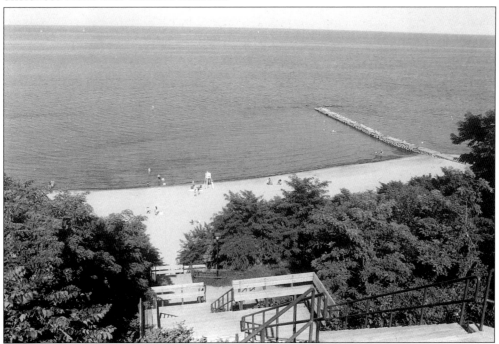

The present-day Atwater Beach may be reached by descending the sturdy wooden steps leading down the bluff. The steps are intermittently spaced with wide landings.

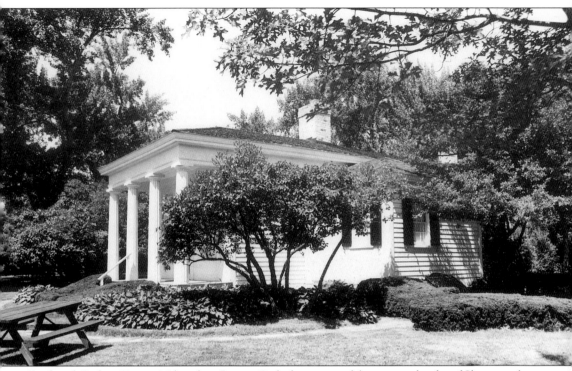

Estabrook Park, a 59-acre Milwaukee County Park, forms part of the western border of Shorewood and lies mostly within the village boundaries. A scenic park ribbon that follows the Milwaukee River from East Capitol Drive to East Hampton Avenue, it is a lovely landscaped area for picnics, games, and enjoyment of nature. The park was designed by Frederick Law Olmsted, who also designed Lake Park in Milwaukee and Central Park in New York City. Just north of Capitol Drive is the Kilbourntown House, built in 1844 and a Wisconsin Registered Landmark. It was relocated to Estabrook Park in 1938 and is open periodically to the public during the summer months, under the supervision of the County Historical Society and/or the Colonial Dames.

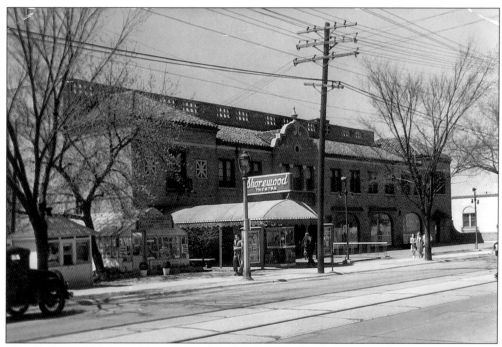

The Shorewood Theater, located at Oakland Avenue and Lake Bluff Boulevard, was opened in 1927 in an ornate, Mediterranean-style building (pictured above). The building also housed a real estate office, the North Shore Publishing Company, a dance hall, and a bowling alley and tavern in the lower level, which was entered from Lake Bluff Boulevard (pictured below). The lobby and interior of the theater were lavishly decorated. A theater balcony was on the second floor. The theater was closed in the 1960s, the victim of television and video recorders, and the building was razed in 1967. In its later years, the building was the site of a skating rink and, briefly, in the late 1940s, it was used by the new Holy Family Parish for services before a church building was finished on Hampton and Wildwood Avenues in Whitefish Bay.

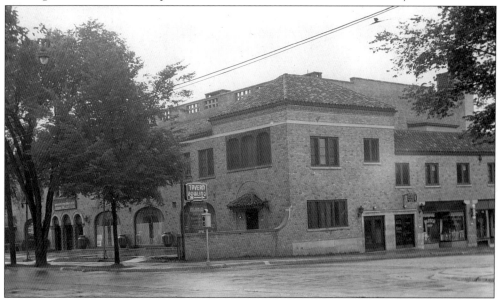

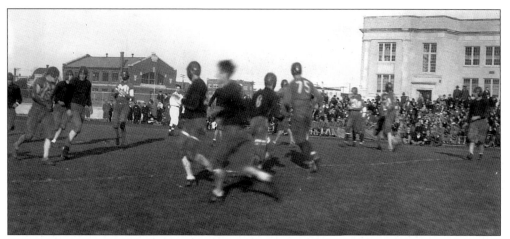

School properties provided spaces for physical activities and sporting events such as football (field west of the high school Science Building pictured), baseball, running, and community swimming activities. (Fall 1929, Armory in left background.)

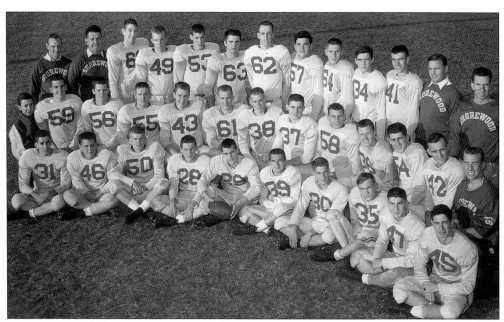

Shorewood High School's 1957 varsity football team, the Greyhounds, tied for the suburban championship with the Waukesha Blackshirts, both finishing with 7-1 records. A highlight of that year was the battle with the Whitefish Bay Blue Dukes. The Greyhounds' victory brought the Glory Cup back to Shorewood. (*Milwaukee Journal* photo.)

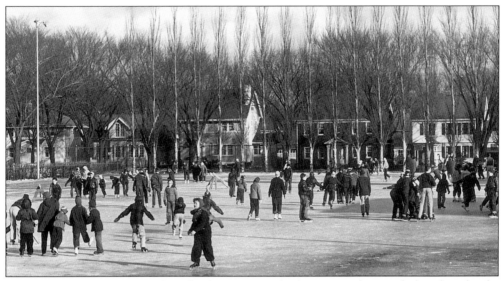

Ice skating rinks were created by flooding fields at both Atwater (pictured above) and Lake Bluff Elementary Schools. These rinks remain popular during winter months. DPW work wagons were hauled in for warming houses in earlier years, heated with potbelly stoves and insulated with bales of straw around the base. (*Milwaukee Journal* photo.)

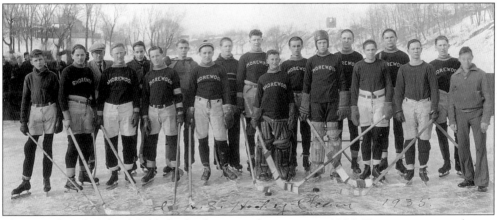

Shorewood High School fielded a hockey team beginning in 1926. Teams won many league championships, and the 1950 team was Southeast Prep champion. In the 1940s, teams played on a rink surrounded by board walls that were set up on the football field. Pictured on the frozen Milwaukee River with sticks and pucks is the 1935 high school hockey team that boasted a 10-3 record. (Photo News Service.)

Eight
VILLAGE POTPOURRI

Englebert Benzing harvests a bumper crop of hay and oats in 1914 at his farm near Lake Bluff Boulevard and Murray Avenue. The farmhouse still stands at 4221 North Murray Avenue. Benzing emigrated from Germany in 1883 at age 19 and worked as a tinsmith, farmer, excavator, and grader, serving on the Village Board and as health officer after incorporation in 1900. Granddaughter Margaret Benzing Johnson is a village resident. (Courtesy of A.J. Breitwish.)

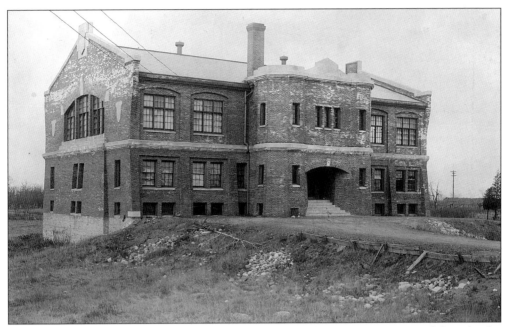

The Armory Building, home to the 105th Cavalry Unit of the Wisconsin National Guard—the Light Horse Squadron—was constructed in 1910 at the location between the present Sendik's and Walgreens on Oakland Avenue. The armory grounds were sold in 1929 when the cavalry and infantry units were combined at a new armory building on North Richards Street. The 30 acres occupied by the National Guard soon became business and residential areas.

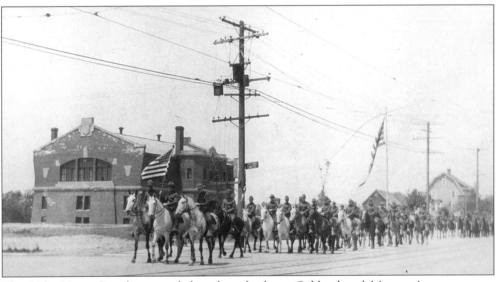

The Light Horse Squadron paraded on horseback on Oakland and Murray Avenues many Sunday afternoons, much to the delight of villagers. Drills and polo games were also held on the fields of the encampment. The grounds contained a commander's home, a custodian's home, the Armory, a drill field, ten lighted horseshoe courts, and East Milwaukee's "pink schoolhouse" (used for a blacksmith and hay storage).

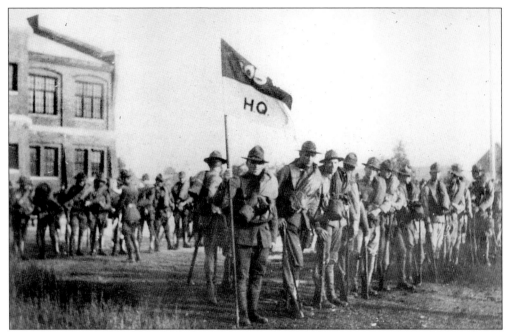

In 1917, the proud soldiers of the 105th Light Horse Squadron gathered in front of the armory building on Oakland Avenue before leaving to serve with United States Armed Forces in World War I.

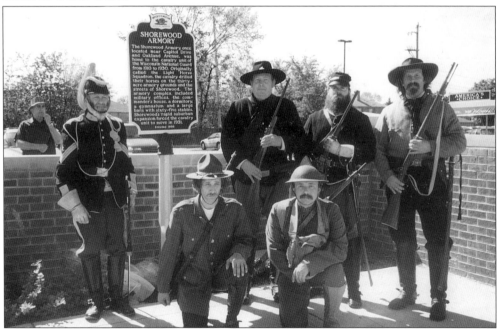

The site of the armory was marked with a State Historical Society sign on May 17, 1998. A six-horse cavalry unit of the Wisconsin National Guard, in full regalia, paraded in Sendik's parking lot, the site of the former armory. The marker was originally placed at the south entrance to Kohl's parking lot, and it now holds a permanent position at the southwest corner of Oakland Avenue and Kenmore Place.

The Gores house at 4525 North Oakland Avenue is the lifelong home of Gladys and Irene Gores. An 1876 plat map shows a structure on the property that belonged to F. Fischer. The property had been purchased in 1868. In this 2000 picture, the Gores home is sandwiched between two business buildings.

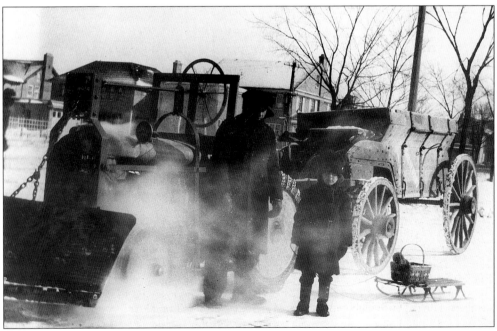

A young girl with her sled stands next to an early dump wagon beside a snowplow.

The Shorewood Masonic Temple was constructed in modern classical style in the 4000 block of Oakland Avenue in 1938. The lodge was organized in 1926 with 65 members. Cornerstone laying in May of 1938 was preceded by a procession from the east end of the Capitol Drive bridge to Morris Boulevard, north to Lake Bluff Boulevard, east to Oakland Avenue, and south to the temple at Oakland Avenue and Kenmore Place.

The American Legion, North Shore Post Number 331, was organized in 1932 with 50 charter members. The red brick clubhouse is located at 4121 North Wilson Drive. Over the years, the post has sponsored drum and bugle corps, supported scholarships, and taken part in other community activities. Post members take part in the annual poppy sale during Memorial Weekend.

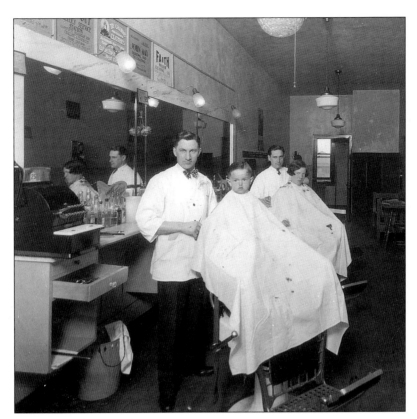

Alfred A. Matter was the proprietor of the Beverly Barber Shop, located at 3815 North Oakland Avenue from about 1929 to 1945. The interior of the shop is pictured here in about 1930. The child having a trim is Don Hodgens, and the second barber is Ervin Preuss. Note the lack of individual sinks, installed later.

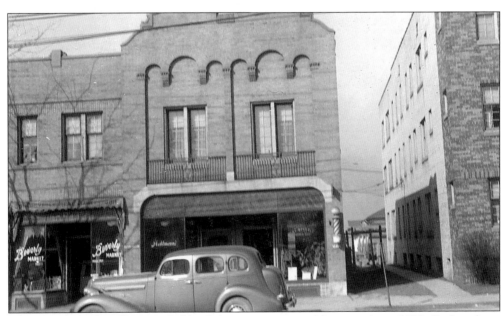

The Beverly Barber Shop on Oakland Avenue is pictured here in about 1930. Barber shops were designated by rotating "barber poles."

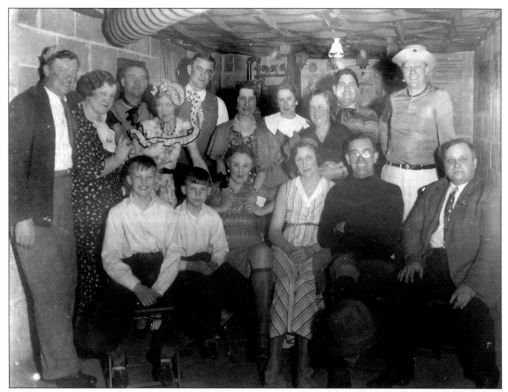

A "Hard Times" party was held in the Mollwitz home basement "rec" room, c. 1936. Pictured here, from left to right, are as follows: (front row) Bob, Dick, and Collette Mollwitz (note the rolled stockings), Clara and Herman Draeger, and Artie Bues (possibly); (back row) Emil and Marie Mollwitz, unidentified couple, Edwin Mollwitz, unidentified woman, Dorothy Mollwitz, unidentified couple, and Fred Mollwitz (a Shorewood policeman).

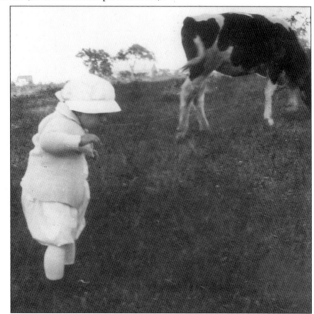

A young girl encounters a Holstein cow in the vicinity of Capitol Drive and Newhall Street in 1921. There were designated sections of the village where livestock could be kept. This was presumably a "livestock allowed" section.

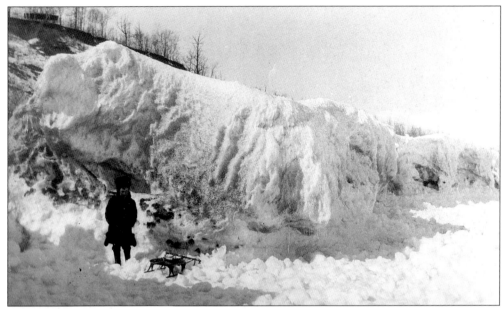

A young girl brought her sled to the beach at the base of the bluff in the winter. The ice mountain was formed by the Lake Michigan waves pushing ice up onto the beach.

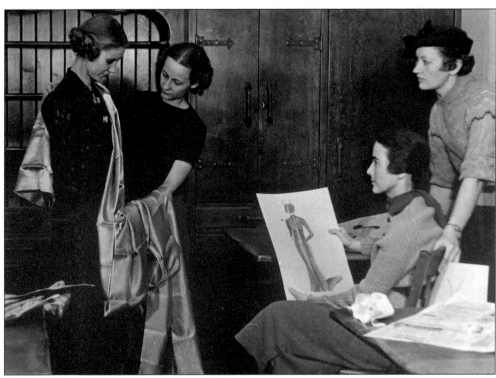

The Shorewood Players, organized in 1925 as an Opportunity School activity, are still active and widely acclaimed in community theater. Performances are held in the Shorewood High School Auditorium. In this picture, members of the players are working with costuming sketches and materials, creating costumes for a production.

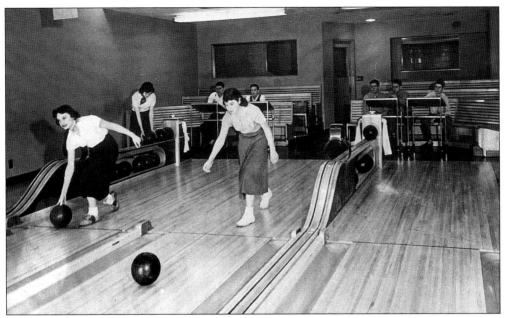

The Shorewood Youth Center was dedicated in 1951, made possible by the addition of a gym to the original Gymnasium Building. The Youth Center was operated with the help of the Student Advisory Council. Dances and other activities were held on Friday nights; Shorewood young people who were not students at the high school were invited. Pictured here are students bowling. The four lanes in the lower level were popular.

At the south end of the Hubbard Park area were an ice chute and conveyer ramp that facilitated the removal of ice blocks from the Milwaukee River. The ice, which was used for refrigeration, was loaded directly onto the adjacent railroad cars or hauled through the tunnel under the tracks to local vendors. This 1922 photo was presumably taken in the summer; swimmers are visible upriver.

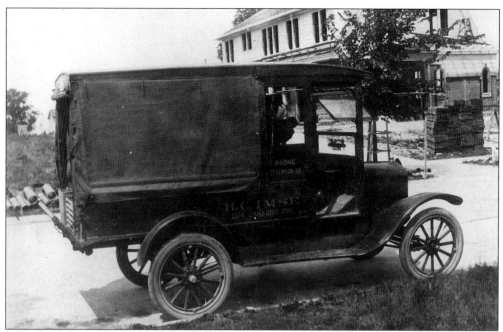

H.C. Imse, owner of this delivery truck, was proprietor of a grocery at 414 Atwater Road, (Capitol Drive and Murray Avenue), phone EDgewood 59, according to an ad in the 1924 Shorewood High School Copperdome yearbook. The address was 1921 East Capitol Drive, following a change in the street numbering system in about 1930 to bring Shorewood street numbers into alignment with City of Milwaukee numbers.

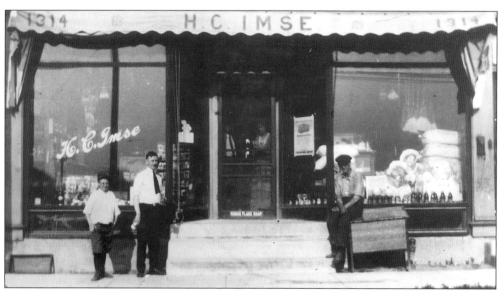

Pictured is the H.C. Imse grocery store at 1314 North Oakland Avenue (corner of Capitol Drive and Oakland Avenue), a previous location of the store.

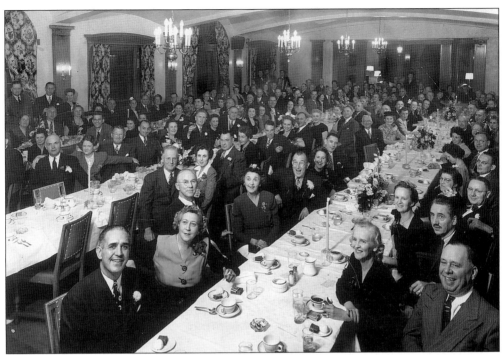

The Shorewood Cooperative Club, a business and professional men's organization, was formed in 1927. The club was described as "intelligent, civilized people cooperating for the common good." It erected the Honor Roll during World War II on the corner of Oakland Avenue and Capitol Drive, provided the Glory Cup trophy for the Shorewood-Whitefish Bay football contest, and helped high school graduates obtain employment. (1945 Installation Dinner, locale unidentified.)

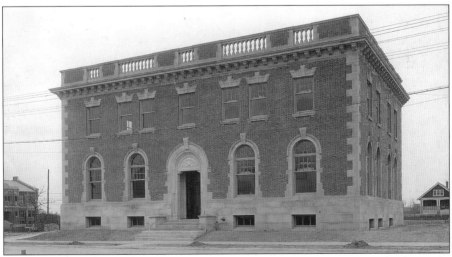

The telephone exchange building on Capitol Drive at Cramer Street once was the workplace for all the operators needed for the EDgewood, CHurch, and WOodruff exchanges, Shorewood's phone connection outside the village limits. With a new facade, it is now an Ameritech building. To the left in this December 5, 1917, photo is the Armory. The home in the right background is on Elmdale Court. (Courtesy of Joseph Brown.)

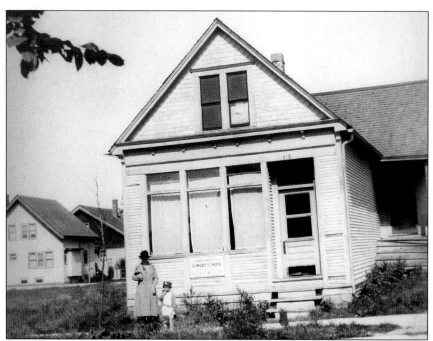

A Presbyterian mission held Sunday school classes in this building, which has long since been razed, on Capitol Drive near Stowell Avenue. The one-story building that replaced it is the present location of Rainbow Jersey bicycle shop. It has housed the A&P and Shoreview groceries and Kincaide's Liquors in the past. The house in the left background is on Prospect Avenue.

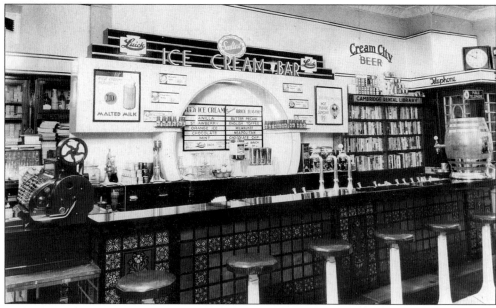

The Hayek Drugstore soda fountain is pictured here in the 1930s. Note the Art Deco fountain area, root beer keg with spigot, faucets that supplied soda for fountain items, and cash register with large wheel of paper tape. Ten varieties of brick ice cream are offered. Luick and Sealtest products are advertised, along with Cream City beer. The fountain was replaced by a freezer case in the 1950s.

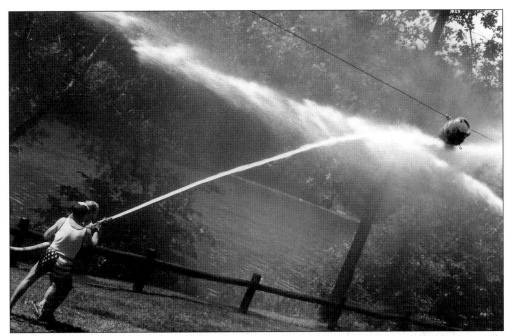

The Fourth of July Family Day festivities take place in Hubbard Park, preceded by a parade through the village. One of the main attractions is the water fight employing fire department hoses and a barrel.

The Shorewood Men's Club has served a chicken barbecue the second Saturday of June at Atwater Park for many years. The barbecue has become an enjoyable summer event for residents as well as joggers, bikers, and motorists traveling Lake Drive. The whole chickens are roasted on long spits over open charcoal fires.

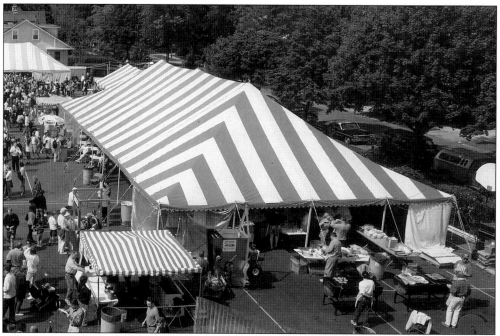

The St. Robert Fair has been a staple of summer entertainment since 1973. Always held the first weekend in June, the fair began as a Sunday afternoon event and has been expanded to include Saturday evening as well. Music, food, games, rides, crafts, raffles, and camaraderie are its hallmarks. The fair is pictured here in a 1998 photo taken from the parish house attic. (© Ken Novak 2000, all rights reserved.)

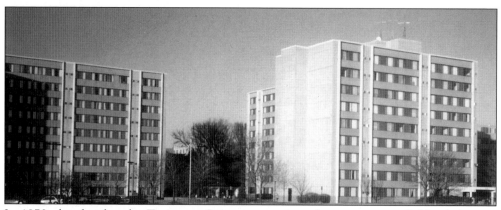

In 1970, shortly after the Transport Company terminated operations on Oakland Avenue near Edgewood Avenue, the village purchased the property. In 1976, the first apartment building was completed, the second in 1978, and the area was named River Park. Shorewood was the first community in the country to qualify for funds under the Housing and Community Development Act, providing direct rent subsidy to people over 62 with qualifying annual incomes.

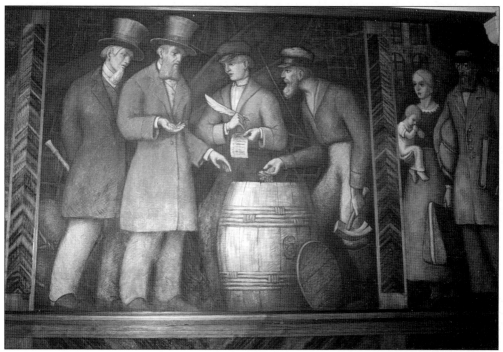

In 1994, the Shorewood Historical Society undertook the project of restoring and preserving the ten WPA murals in the lobby of the Shorewood High School Administration Building. *On Wisconsin* was executed by Carl Van Treeck in the 1930s. Shown here is a section of a mural on the east wall—*Wisconsin at the Middle of the Nineteenth Century*, a harbor scene, with businessmen inspecting grain.

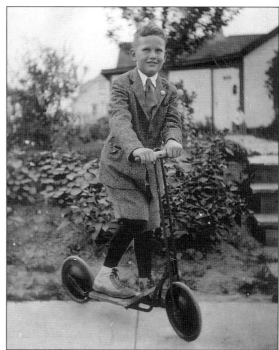

Lester Mollwitz was a young boy in the 1920s, when he wore his Sunday best (a four-in-hand necktie, white shirt, canvas high-top shoes, and a knickers suit) and rode his scooter past the Gores home on Oakland Avenue.

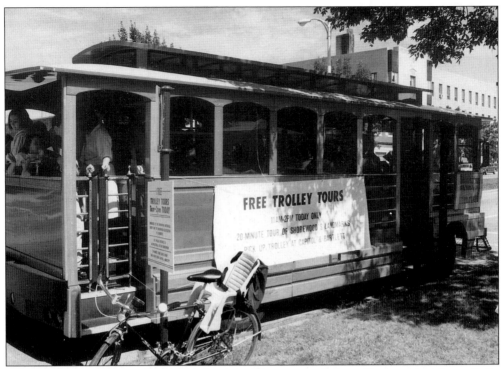

The Shorewood Historical Society directs trolley tours of the village at the time of the Shorewood Showcase in the fall. The Showcase, organized by the Shorewood Association of Commerce, highlights Shorewood businesses and organizations. Open, old-fashioned trolleys like this one, pictured in 1993, are leased for the occasion.

A highlight of the Fourth of July Parade is the sight of village dignitaries riding in open convertibles. In 1993, Tom Brill, retired former owner of Harley's Men's Shop and president of the Association of Commerce at that time, and Dorothy May, retired director of the Shorewood Health Department and president of the Shorewood Historical Society at that time, rode in the parade. Brill is natty in patriotic colors; May is elegant in period clothing.

A calf belonging to the Gores family is pictured at their farm on Oakland Avenue on March 10, 1912.

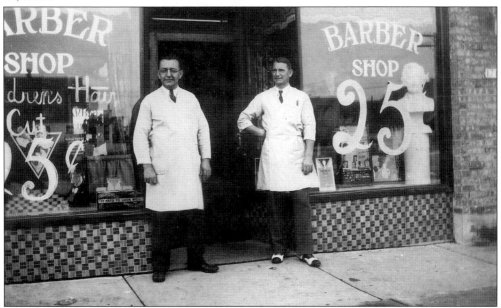

The Charles Westerlund Barber Shop was located in the Shorewood Theater building on Oakland Avenue at Lake Bluff Boulevard. In this 1932 photo, the two barbers stand in front of the store window that advertises "Children's Hair Cut 5¢." On the other window is "25," presumably the price of an adult hair cut.

In the 1920s, Maryland Avenue, as it continued out of Shorewood to the south, was mud. Edgewood Avenue, in the foreground, appears to be graded. In the background is Columbia Hospital, rising skyward at Maryland and Hartford Avenues. To the left is the fence that surrounds Downer Woods, a wooded area belonging to Downer College, now part of the UWM campus. Downer Woods was the site of the annual "hat hunt" by Downer College coeds.

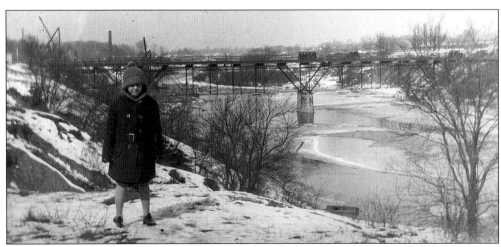

Capitol Drive crossed the Milwaukee River on an iron bridge in 1924. The bridge was replaced by a concrete bridge in 1927 and again in 1983. The most recent renovation occurred in 1997.

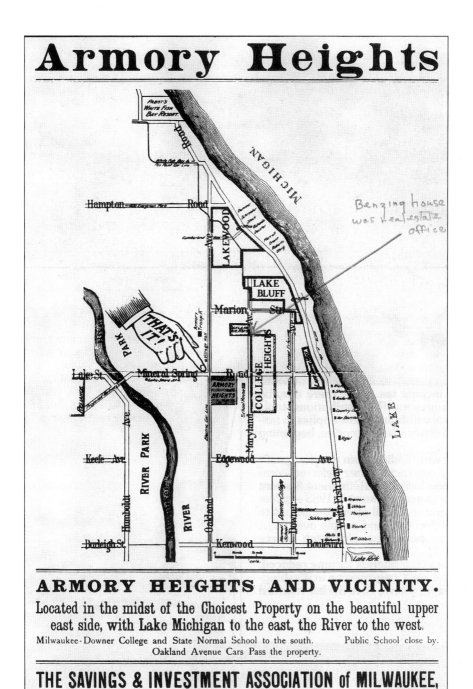

This 1911 poster for the Armory Heights subdivision lists many highlights of the area—schools, streetcar lines, etc. A lot could be purchased for $435, "$10 down, $2 a week, no interest at any time, no pay when sick." This area is the southwest corner of Oakland Avenue and Mineral Spring Road (now Capitol Drive). The real estate office was in the Benzing home on Murray Avenue (now 4221). The map shows some of the other subdivision names, street names, points of interest such as the village hall and armory on Oakland Avenue, and the grade school on Murray Avenue.

Children enjoyed the elliptical-shaped wading pool in a miniature community park at Lake Bluff School. The pool, constructed in 1931 as the central point of interest in the park, was 70-by-32 feet at its widest point, 6 inches deep at one end and 12 inches at the other. The project expense was $1,400. The pool was closed during the polio epidemics of the 1940s.

The Shorewood Banner (right), designed and executed by Shorewood Historical Society member Nan Hayek, was hung with other society banners in the rotunda of the Wisconsin State Capitol during the 1998 Sesquicentennial Celebration. The appliques on the banner highlight the Shorewood High School Copperdome, Village Hall, and a Cavalry soldier representing the Armory. The high school campus, the Village Hall, and the Armory each received historic designation from the State Historical Society.

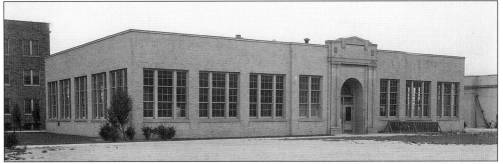

Occupied in fall of 1924 and completed in 1925, the Shorewood High School Manual Arts Building served the art department, the woodworking classes, and the metal shop. It also housed machinery for the machine shop. Until a heating system could be put into operation, large stoves in each of the four rooms heated the building. It was located south of the high school parking lot.

The Gellman-Nasgovitz Shorewood Community Fitness Center was dedicated in March of 1998. Housed in the former Manual Arts Building, the facilities are available to individuals, families, and high school students. It includes a main exercise room, an aerobic/dance studio, a classroom, and locker rooms.

In 1930, by popular vote, the zinnia became the village's official flower. In 1988, the Shorewood Historical Society urged the planting of zinnias, and members roamed the village photographing zinnia plantings. This poster advertised the zinnia at the Atwater Antique Show in the spring. In 2000, the Centennial year, the society distributed packets of zinnia seeds at the spring primary election voting locations in the village.

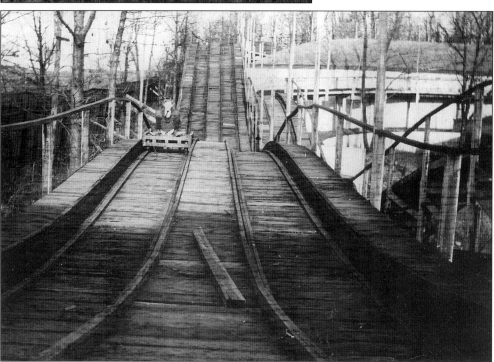

In disrepair, the wooden roller coaster is pictured here sometime after Ravenna Park closed in 1916. The exciting ride had been constructed when the park was purchased by the Summer Amusement Company in 1900. Coney Island was succeeded by Wonderland in 1905 and Ravenna in 1909. (Courtesy of Reinke Collection.)